Terrific Stencils & Stamps

Jo'Anne Kelly

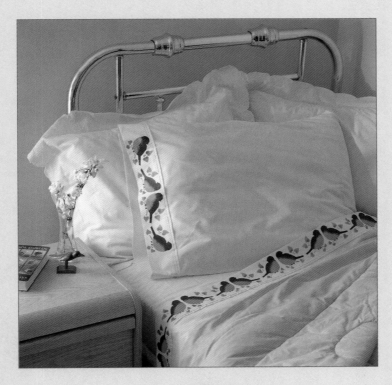

Sterling Publishing Co., Inc. New York

A STERLING/TAMOS BOOK

A Sterling/Tamos Book
© 1996 Jo'Anne Kelly

Sterling Publishing Co., Inc.
387 Park Avenue South,
New York, NY 10016 8810

TAMOS Books Inc.
300 Wales Avenue, Winnipeg, MB,
Canada R2M 2S9

10 9 8 7 6 5 4 3 2 1

Distributed in Canada by Sterling
Publishing Co., Inc.
c/o Canadian Manda Group
One Atlantic Avenue, Suite 105
Toronto, Ontario, Canada M6K 3E7
Distributed in Great Britain and
Europe by Cassell PLC
Wellington House, 125 Strand, London
WC2R 0BB, England
Distributed in Australia by Capricorn
Link (Australia) Pty Ltd.
P.O. Box 6651, Baulkham Hills,
Business Centre, NSW 2153, Australia

Design Arlene Osen
Illustrations Teddy Cameron Long
Photography Jerry Grajewski,
Custom Images Ltd.
Printed in Hong Kong

*Canadian Cataloging-in-Publication
Data*
Kelly, Jo'Anne, 1937–
 Terrific stencils & stamps
 "A Sterling/Tamos book."
 Includes index.
 ISBN 1-895569-38-9
1. Stencil work. 2. Hand stamps.
I. Title.
TT270.K44 1996 745.7'3
C95–920210–2

*Library of Congress Cataloging-in-
Publication Data*
Kelly, Jo'Anne.
 Terrific stencils and stamps/
 Jo'Anne Kelly.
 p. cm.
 "A Sterling/Tamos book."
 Includes index.
 ISBN 1-895569-38-9
1. Stencil work. 2. Relief printing.
I. Title.
TT270.K45 1996 95–26033
745.7'3--dc20 CIP

ISBN 1-895569-38-9

Contents

Introduction

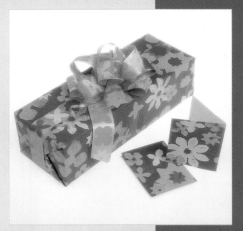

Creating delightful stencils and stamps to do your own decorating adds drama and excitement to household and personal items. You can give your own special touches to clothing, furniture, gifts, even gift wrap.

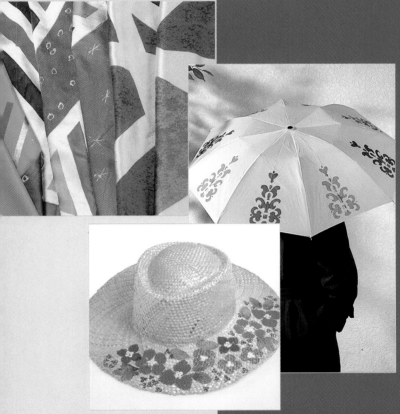

Besides producing spectacular objects you'll also save money. These special decorating stencils and stamps cost only pennies to make from materials found around the house or in fabric and craft stores. Use a floral design to decorate newspaper for gift wrap, cards, and ribbon, animals for a child's room, a geometric pattern for a scarf, vines for a serving tray retrieved from a secondhand store, a floral motif for a canvas floor mat and window shades. You can make all these attractive and useful projects and much more. It's easy to do and fun to create.

Learn how to design and make stencils and stamps, how to create your own patterns, how to combine stencils and stamps in one project, and how to finish the products to make them useable and lasting. Even children can participate with a little help from an adult. Just follow the simple step-by-step directions in this book. All the techniques are described so you can use these basics to make the patterns given or create something entirely different. Color combinations are suggested, but you can choose different colors to blend with your decor or suit your color preference.

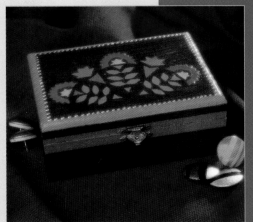

Making attractive and unusual stencils and stamps can take you to the limits of your imagination. Applying them to objects will create lasting beauty to be enjoyed by family and friends for many years.

Tools Equipment

A SELECTION OF BRUSHES a small pointed brush for touch-ups and detailing; 1/2 in to 2 in flat bristle brushes or 1 in to 1-1/2 in polyfoam brushes to apply paint to stamp surfaces; and 3/16 in, 3/8 in, and 3/4 in round, stiff-bristled stencil brushes with flat ends

SPONGES a variety of inexpensive fine-grained and coarse-grained sponges that can be cut to different sizes

ROLLERS small foam rollers for paint application and large paint rollers

CRAFT KNIVES utility knife with easily replaceable blades to cut stencils, a larger snap-off blade style knife for cutting styrofoam, and a small handsaw to cut wooden dowels or buffalo board

SCISSORS sharp shears for cutting fabric and small sharp scissors for cutting paper stencils

GLUES good quality washfast fabric glue, wood glue, and repositionable spray adhesive

• paper towels, wax paper, tracing paper, bond paper, clear mylar, card stock, carbon paper, newspaper, sandpaper, 1/2 to 1 in rigid styrofoam, 1/4-in-thick heavy felt

• ruler, waterproof fine-tipped felt marking pens, ballpoint pens, pencil, eraser, straight pins or push pins, masking tape, cotton swab sticks, chalk (regular and dressmaker's)

• plastic basin, containers, jars, tin cans

PAINTS acrylic: tubes, jars, bottles; fabric paints, fabric dimensional paints; spray paints; stencil paints, latex paints, acrylic enamel paints

• paint tray or plastic plate

• painter's mask

• Dylon cold dyes, Dylon fix (or washing soda and baking soda), sweet rice flour or cornstarch

• clear acrylic varnish and acrylic varathane, lacquer thinner

• plastic sheeting

• buffalo board or acoustic ceiling tiles, window glass

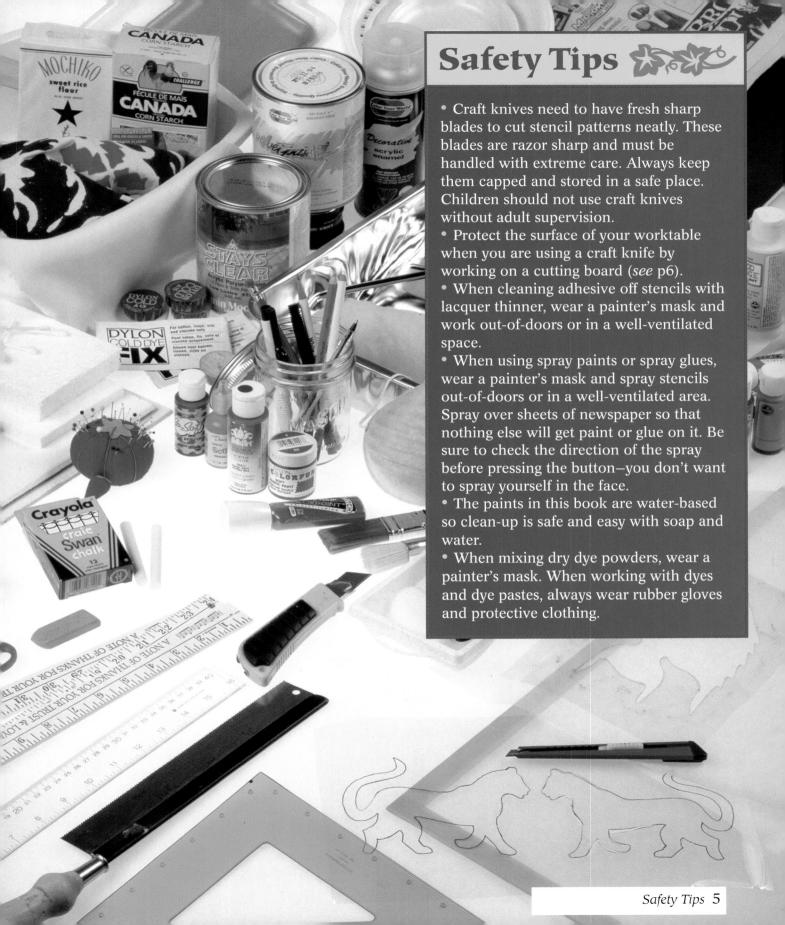

Safety Tips

- Craft knives need to have fresh sharp blades to cut stencil patterns neatly. These blades are razor sharp and must be handled with extreme care. Always keep them capped and stored in a safe place. Children should not use craft knives without adult supervision.
- Protect the surface of your worktable when you are using a craft knife by working on a cutting board (*see* p6).
- When cleaning adhesive off stencils with lacquer thinner, wear a painter's mask and work out-of-doors or in a well-ventilated space.
- When using spray paints or spray glues, wear a painter's mask and spray stencils out-of-doors or in a well-ventilated area. Spray over sheets of newspaper so that nothing else will get paint or glue on it. Be sure to check the direction of the spray before pressing the button—you don't want to spray yourself in the face.
- The paints in this book are water-based so clean-up is safe and easy with soap and water.
- When mixing dry dye powders, wear a painter's mask. When working with dyes and dye pastes, always wear rubber gloves and protective clothing.

Preparing a Work Surface

Choose a waist-high table or workbench and cover with sheets of newspaper. Have a supply of clean tin cans or plastic containers to hold paint brushes, glue tubes, pins, scissors, straightedge, tape measure, craft knife, markers, and other supplies.

Tackboard made from buffalo board (available in sheets from a lumberyard cut to the size you need) for larger projects or smooth non-patterned 2 ft x 4 ft acoustic ceiling tiles for smaller projects. NOTE Several dye-printed fabric projects require a large tackboard (4 ft x 8 ft).

1 Place the board or tile on the work surface and cover with several sheets of newspaper or a sheet of plastic that can be discarded.

2 Use straight pins to hold materials in position while working.

Cutting board made from a sheet of glass with taped edges to avoid cutting your hands or purchase a commercial household cutting board.

1 Place the board on the work surface.

2 Place material to be cut on the cutting board and carefully cut along cutting lines with a craft knife.

Choosing Paints

Latex paints are water-based, non-toxic, inexpensive, and easily cleaned up. They are available at any paint or hardware store. Check the miss-tints section for bargains and unusual shades. These paints are best used on nonfabric surfaces.

Acrylic paints are more expensive but come in a wonderful array of colors in tubes, jars, and small bottles. They are also available in metallic and pearlized colors. They can be purchased at craft and art supply stores. Acrylic enamel paints are useful for furniture projects.

Fabric paints are acrylic-based paints developed to paint on fabric surfaces without making the fabric too stiff. Follow the manufacturer's instructions for setting colors to make them washable.

Fabric dimensional paints come in squeeze bottles in an array of colors and can be used to add decorative touches.

Spray paints can be water-based acrylic (these are less toxic) or lacquer-based. Use spray paints outdoors or in a well-ventilated room. Always wear a painter's mask.

Stencil paints are specially prepared for use with stencils. They are available at craft and home decorating stores.

NOTE Paints used for stencilling projects should be creamy rather than runny in consistency.

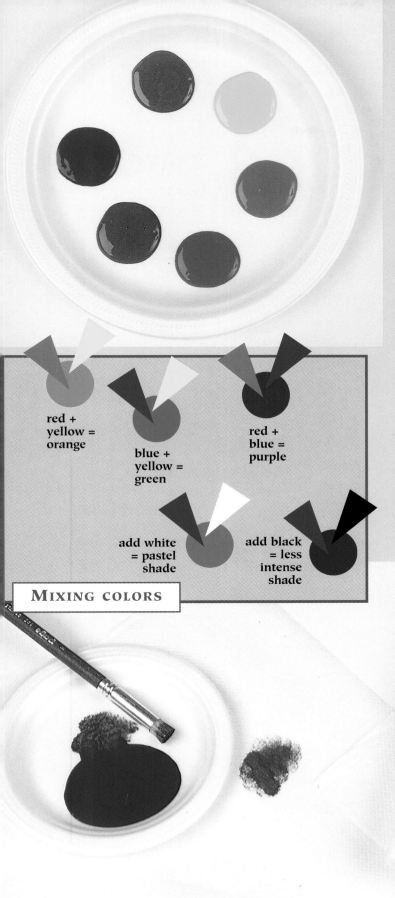

Mixing Paints

Acrylic paints are expensive so buy basic colors (red, yellow, blue, white, black), and mix them to achieve other hues. *See* diagram. You may wish to gradually add other colors to your supply. NOTE Mixing different kinds of acrylic paints may affect their characteristics. For example, adding tube acrylic to fabric paint makes a thicker mixture for a project with a smooth hard surface, but makes fabric surfaces stiffer, which may not be appropriate for your project.

How to Use Paints

For most projects a plastic plate will function as a paint tray. For larger projects requiring a roller, a commercial painter's tray is more suitable for paint and dye pastes.

1 Pour or squeeze a small amount of paint into the tray and dip in brush, sponge, or roller. *Do not overload*.

2 For stencil projects requiring a dry brush application, dab excess paint onto newspaper or a paper towel. For stamp projects, apply a thin even coat of paint to the surface of the stamp using a roller, brush, or sponge and print on the surface to be decorated.

If you are combining colors, it can be done in the tray, using a flat brush as a spatula.

red +
yellow =
orange

blue +
yellow =
green

red +
blue =
purple

add white
= pastel
shade

add black
= less
intense
shade

MIXING COLORS

Dylon Cold Dye Pastes

Dye pastes are fabric dyes that have been thickened into paste in order to print or stencil onto fabric without spreading. They are washfast only on natural fibers such as cotton, linen, silk, and viscose rayon. Dye pastes can be stencilled or stamped onto natural fabrics using brushes or rollers in the same manner as fabric paints.

NOTE Background color will affect dyed color of material.

The recommended thickener for Dylon Cold Dyes is sodium alginate. However, the following recipes will work successfully for projects in this book. When using these recipes, *do not substitute other brands of dye* because the necessary chemical reaction cannot be guaranteed.

How to Dye-Print Fabric

1 To prepare fabric for dyes, soak 5 minutes in a plastic basin filled with 2 quarts water to which 2 packages of Dylon Cold Fix has been added. (In place of Dylon Cold Fix you can use 4 teaspoons of baking soda and 1 teaspoon of washing soda dissolved in 1/2 cup of boiling water) For large lengths of fabric, double recipe. Wring out.

2 Stretch on tackboard and pin down. Allow to dry before printing.

3 Pour small amount of dye into paint tray. Dip in brush or roller, do not overload.

For stencil projects, dab or roll excess dye paste on brush or

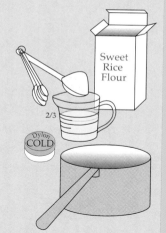

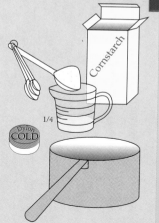

Dye Paste Thickener Recipe 1

In a large pan place 3 rounded tablespoons of sweet rice flour and gradually stir in enough cold water to make a smooth paste (1/3 cup). Then add 2/3 cup of warm water and mix thoroughly. Place the pan over medium heat, stirring constantly until mixture thickens. Continue to cook and stir over low heat for one minute. Remove from heat and cool.

Add powdered Dylon Cold Dye to this mixture using proportions recommended in the individual projects. Stir until fully blended. Store in covered containers in a cool place and *use within 6 hours* as dye intensity reduces with time. Stir well before each use.

CAUTION When preparing and applying dye pastes be sure to wear rubber gloves and a protective apron.

Dye Paste Thickener Recipe 2

In a large pan, mix 2 rounded tablespoons of cornstarch into 1/4 cup cold water. Stir until dissolved. Add 3/4 cup warm water and stir. Place the pan over medium heat and bring to a boil, stirring constantly. Continue to boil for one minute to thicken. Remove from heat. Cool.

Follow instructions in Recipe I for adding Dylon dye, storing, and using.

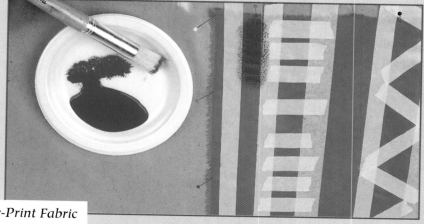

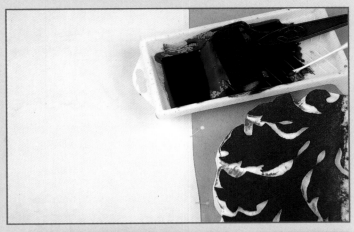

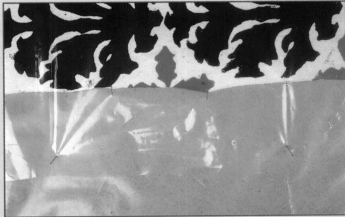

roller onto newspaper.

For stamp projects, use a roller to apply dye paste to stamp surface. Coat evenly, but thinly. Clean excess dye build-up from edges of stamp with a brush or cotton swab stick.

4 After fabric is printed cover with a plastic sheet and allow to set overnight to develop the full color intensity. Remove sheet and let fabric air dry.

5 Wash in several baths of water and gentle, nonbleaching detergent. Begin with cold water, keeping the water running until excess dye stops washing out. Stir constantly. Repeat with warmer water, then hot water. Rinse. Wring out gently. Hang the dye-printed fabric to dry or tumble dry.

Choosing Glues

Use a good quality fabric glue to make stamps. It dries rapidly and is water-resistant. Use a repositionable spray adhesive to coat the back of stencils to help adhere them to the surface to be stencilled and prevent paint seepage. Do not overspray. Wait a few minutes for the tack to develop. For projects using wood, a wood glue is recommended. Read all instructions on glue label.

How to Use Patterns

The patterns in this book are on a grid and can be made smaller or larger to suit your project (*see* p65). Patterns can also be reduced or enlarged on a photocopy machine.

Enlarge or reduce pattern required using one of the above methods. Trace the pattern onto the stencil material using carbon paper. If the material is transparent (such as clear mylar), you can trace right onto the film with a waterproof fine-tipped felt pen. For stamps, trace the patterns onto bond paper, cut them out, lightly coat backs with respositionable spray glue, and adhere to felt for cutting.

Finishing the Project

Some projects require a protective coating to make them more durable. A layer of clear acrylic varnish applied with a bristle or polyfoam brush will usually suffice. For projects that will undergo heavy wear, such as floor mats or furniture, use 3 coats of acrylic varathane. Allow each coat to dry before adding the next. Wash the brush with soapy water.

Fabric paints on fabrics need to be set or made washfast. Some can be air cured over a period of 2 or more days without washing. Others can be set by ironing on the wrong side for about 3 minutes or by placing in a clothes dryer at high setting for 1/2 hour. Be sure to follow the manufacturer's instructions.

How to Make Stencils

Mylar is a clear strong plastic (available at art supply stores) and is the recommended stencil material for many projects in this book. It is long-wearing, easy to cut with a craft knife, and transparent for accurate placement on the project.

If mylar is not available, the following materials can be used: card stock, manilla card, file folders, coated freezer paper, or clear vinyl (available at fabric stores).

Patterns that require folding and cutting use bond paper. Bond paper is not a strong material and requires some additional strengthening. This will allow the pattern to be used more than once.

From bond paper

1 To strengthen the paper and make it waterproof, pin the paper to the tackboard (p6). Have a large enough piece of stencil material to allow for generous borders around the pattern to prevent painting over the edges. Using a small paint brush, paint both sides with acrylic varnish. Brush out all ridges or lumps. Allow each side to dry thoroughly before turning over.

2 Place the strengthened paper on a clean work surface. Lay carbon paper over it and place the enlarged or reduced pattern (p65) on top. Tape down the corners with masking tape to prevent movement. Trace the pattern with a ballpoint pen.

3 Remove the pattern and cut out the stencil with small sharp scissors.

From mylar and transparent materials

1 Have a large enough piece of stencil material to allow for generous borders around the pattern. Place stencil material over the pattern and trace with a waterproof fine-tipped felt pen.

2 Remove the pattern and place stencil on cutting board. Cut out the stencil carefully with a sharp craft knife. Cut out smallest sections first. Lift knife as infrequently as possible, turning the stencil, not the knife, while cutting. Use fresh blades and change as soon as they drag on the stencil material.

3 If you make a mistake or tear the stencil, repair it by pressing clear, reinforced packing tape onto the upper side of the affected area. Re-cut the pattern through the tape.

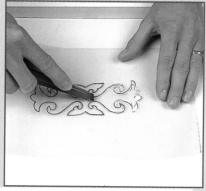 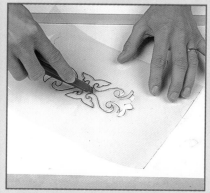

From non-transparent heavy materials

1 Enlarge or reduce pattern (p65).

2 Place the stencil material on the work surface. Lay the carbon paper over it and place the tracing paper pattern on top. Trace the pattern with a ballpoint pen.

3 Cut out stencil with craft knife as for mylar.

How to Use Stencils

Stencils are easier to use if they have a tacky underside that can be pressed onto the surface being stencilled. This helps prevent movement on the project or seepage when paint is applied. To make the stencil tacky, lightly coat the underside with repositionable spray adhesive. This is available at stationery and craft stores. Store tacky stencils with sticky side down on wax paper. They are easily released from this surface.

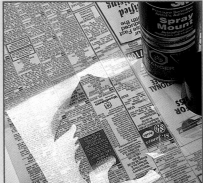

Practice stencilling techniques and test new stencils on paper first.

1 Position the tacky side of stencil on surface to be stencilled. Then press down firmly.

2 Pour paint or dye paste in the paint tray.

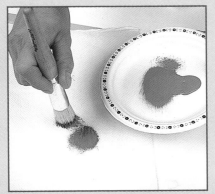 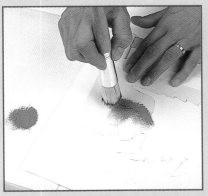

3 Dip in stencil brush, roller, or sponge, being careful not to overload with paint. Stencilling is essentially a "dry brush" technique so remove excess paint on brush, roller, or sponge, by dabbing or rolling on newspaper.

If using a brush or sponge, hold it upright and use an up-and-down movement to dab or **stipple** paint in stencil openings.

If using a roller, coat sparingly and apply very little pressure.

Work from edges of stencil inward.

4 Keep stencils clean by regularly wiping off the paint build-up along the edges. Do this with stencils placed sticky side down on wax paper.

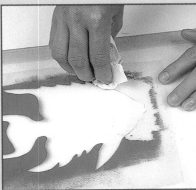 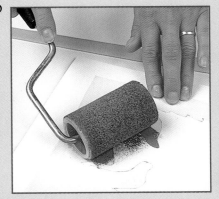

5 Clean stencil brushes, rollers, or sponges in warm, soapy water. Dry thoroughly before using again.

6 If the adhesive build-up becomes too thick, it can be cleaned off with lacquer thinner. Be sure to wear a painter's mask and work in a well-ventilated area.

How to Make Stamps

All stamps are made in the same way. They have a raised surface that creates the pattern and this is glued to a firm base to give the stamps support.

Base Use rigid styrofoam that is 1/2-in thick (available at craft supply stores) or rigid foam insulating board (available 1 in thick at lumberyards). NOTE 1-in thick material is best for stamps that will receive a lot of use. Select undented surfaces.

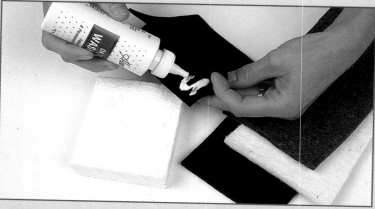

Place the base material on the cutting board (p6). Using a craft knife, cut the base material into the approximate size to suit the pattern.

Pattern Stamp patterns can be made from string, plastic bubble wrap, thick fabric, foam, or any other material thick enough to create a raised pattern.

When making stamps using the patterns given in this book, select heavy felt available at craft stores and many fabric stores. Wool felt coating fabric works well. If felt is not thick enough to make a good stamp impression, glue 2 layers together with fabric glue.

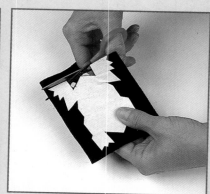

1 Enlarge or reduce pattern (p65) as required for the project. Using tracing paper, trace pattern for stamp onto bond paper and cut out around edges of pattern.

2 Spray patterns on one side lightly with repositionable spray adhesive and adhere to heavy felt.

3 Cut around paper patterns with scissors and remove paper.

4 Glue the pattern to the styrofoam base with fabric glue. Allow to dry.

5 With a craft knife, carve away any edges of the styrofoam base that may interfere with printing the pattern.

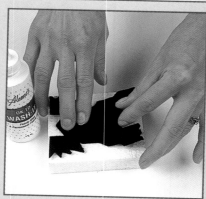

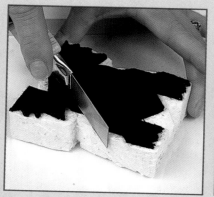

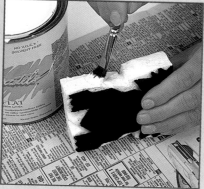

6 Coat the styrofoam base with latex paint to prevent crumbling. NOTE The printed pattern will be the mirror image of the stamp.

How to Use Stamps

1 Pour paint or dye paste in the paint tray. Use a small roller or brush to transfer the paint onto the stamp's printing surface. Coat the surface evenly but sparingly.

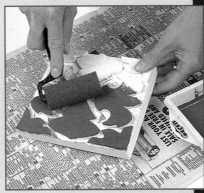

Practice stamping techniques and test new stamps on paper first. A new stamp may require paint or dye-paste applied and stamped on scrap paper two or three times in order to distribute the color evenly over the stamp surface.

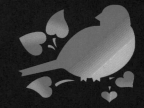

2 Press the stamp onto the surface to be printed, exerting firm but gentle pressure. Cover large stamps with a board or a book and

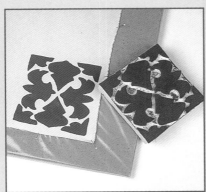

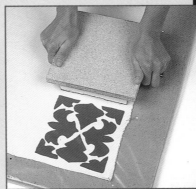

press down firmly to equalize pressure. Wipe away any paint build-up along the edges of the raised pattern as you work. A cotton swab stick works well in crevices.

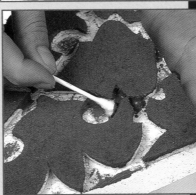

3 When the material is printed, wash the paint from the stamp in warm soapy water, making sure all the color is out. Press stamp on paper towels to remove excess moisture. Allow to dry.

Do not poke or press the working surface of the stamp, as this may dent the underlying styrofoam, creating areas that will not print.

NOTE When using stamp patterns, remember you will not necessarily have crisply defined edges. Irregularities of line and texture are the hallmark of hand-made products and these stamped patterns create a charming rhythmic design without rigidity.

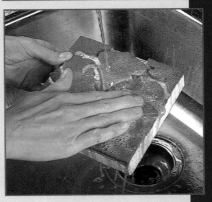

Stencil

Projects

Brooches • Earrings

MATERIALS

5 in piece of balsa wood, 1 in wide • ruler • sharp pencil • craft knife • fine sandpaper • clear acrylic varnish • flat brush, 1/2 in wide • 1 small tube each of acrylic paint—red and metallic gold • good quality masking tape • cutting board (p6) • spoon • paint tray • stencil brush, 3/16 in wide • 1 pin back • 1 pair of earring studs (available from craft stores) • wood glue

1 Using a ruler, pencil, and craft knife, measure and cut a 1 in x 3 in section of balsa wood and 2 smaller pieces each 1 in x 1 in. Balsa wood is available at craft stores.

Sand the surface and edges, slightly rounding the corners.

Coat the surfaces with acrylic varnish to seal the wood. Allow to dry.

Paint the entire surfaces with metallic gold paint. Allow to dry for at least 24 hours. NOTE *A metallic gold felt pen can be used in place of metallic gold paint.*

2 Unroll 6 in of masking tape and adhere to the cutting board.

Using a craft knife and the ruler as a guide, cut strips in various widths. Cut into lengths slightly longer than the balsa brooch and earrings pieces.

Lay down these strips of varying widths of tape along the surfaces of the brooch and earrings in parallel rows.

Adhere the tape edges to the surface by pressing down firmly and rubbing a hard smooth object (the back of a spoon) along the edges.

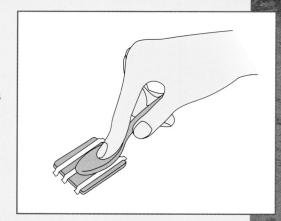

3 Pour red paint into paint tray. Dip stencil brush tip lightly into paint and stipple (p11) in the spaces with red acrylic paint.

4 Carefully lift off the tape. Allow to dry thoroughly.

5 Coat with clear acrylic varnish. Glue the pin back to the brooch and the studs to the earrings.

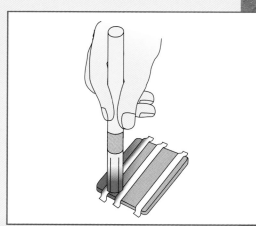

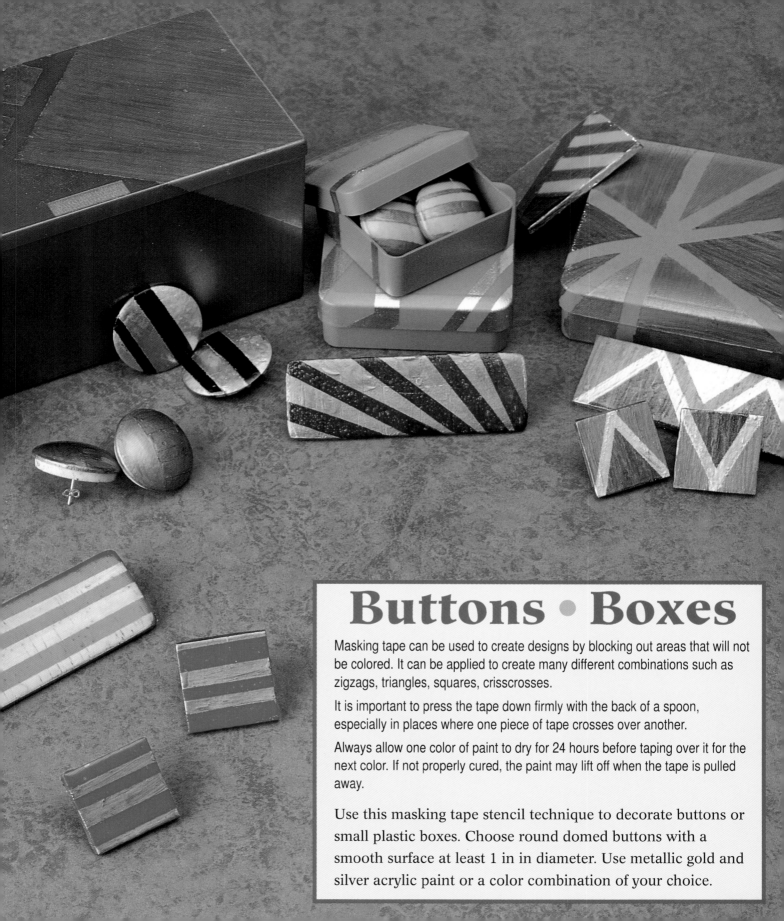

Buttons • Boxes

Masking tape can be used to create designs by blocking out areas that will not be colored. It can be applied to create many different combinations such as zigzags, triangles, squares, crisscrosses.

It is important to press the tape down firmly with the back of a spoon, especially in places where one piece of tape crosses over another.

Always allow one color of paint to dry for 24 hours before taping over it for the next color. If not properly cured, the paint may lift off when the tape is pulled away.

Use this masking tape stencil technique to decorate buttons or small plastic boxes. Choose round domed buttons with a smooth surface at least 1 in in diameter. Use metallic gold and silver acrylic paint or a color combination of your choice.

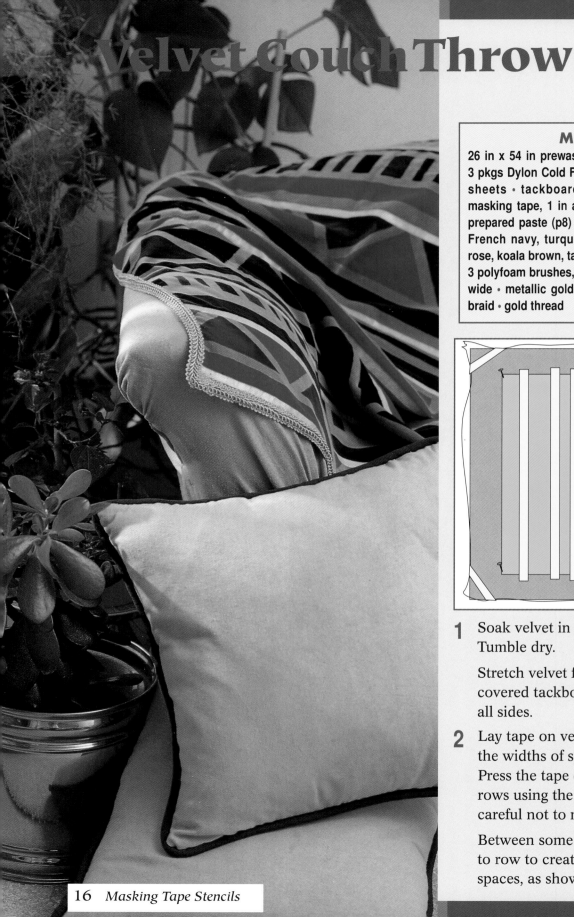

Velvet Couch Throw

MATERIALS

26 in x 54 in prewashed gold-colored cotton velvet • 3 pkgs Dylon Cold Fix • plastic basin • 2 large plastic sheets • tackboard (p6) • straight pins • 2 rolls masking tape, 1 in and 5/8 in wide • spoon • 3 cups prepared paste (p8) • 1 tin each of Dylon Cold Dye—French navy, turquoise saga, Mexican red, bronze rose, koala brown, tartan green • 6 plastic containers • 3 polyfoam brushes, 1 in wide • flat paint brush, 3/4 in wide • metallic gold acrylic fabric paint • 5 yds gold braid • gold thread

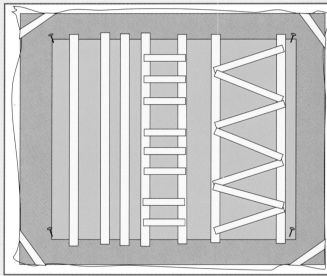

1 Soak velvet in fix solution (*see* p8). Tumble dry.

Stretch velvet fabric taut over a plastic-covered tackboard and pin down along all sides.

2 Lay tape on velvet in parallel rows, varying the widths of spaces and the tape widths. Press the tape down securely all along the rows using the back of a spoon, being careful not to mark the velvet.

Between some rows cross the tape from row to row to create rectangular and triangular spaces, as shown.

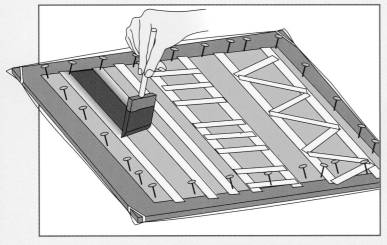

3 Mix 1 tin dye into 1/2 cup prepared paste for each color.

4 Using a polyfoam brush, paint on the dye pastes one color at a time in the lines and spaces not covered by tape. Use a clean polyfoam brush for each color.

5 Carefully cover the painted velvet with a sheet of plastic. Leave overnight. Remove plastic and allow to air dry.

6 Remove the tape carefully, pulling *with* the nap of the velvet.

Wash as directed on p9. After this procedure the painted velvet can be machine washed and tumble dried on the gentle cycle.

7 Stretch the dye-painted velvet on the tackboard and pin down.
Tape down double rows of tape where gold lines will be, allowing varying size spaces between the rows (none wider than 1/2 in).

8 Using a 3/4 in paint brush, apply metallic gold fabric paint to the spaces between the tape. Allow to dry. Carefully remove tape. Set the paint according to manufacturer's instructions.

9 Finish by turning under edges, hemming, and attaching gold braid.

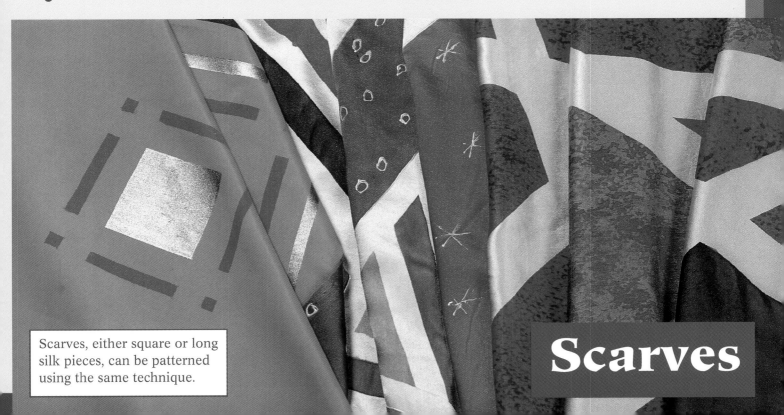

Scarves, either square or long silk pieces, can be patterned using the same technique.

Scarves

Toss Pillow Cover

MATERIALS

1/2 yd prewashed beige heavy silk, 36 in wide · 2 pkgs Dylon Cold Fix · plastic basin · 2 plastic sheets · tackboard (p6) · straight pins · 2 rolls masking tape, 2 in and 1 in wide · cutting board · craft knife · spoon · 2 cups prepared paste (p8) · 1 tin each of Dylon Cold Dye— tartan green, sahara sun, koala brown, mandarin · 4 plastic containers · paint tray · small polyfoam roller · metallic gold fabric paint · coarse sponge · paper towels · 4 tassels

1 Soak silk fabric in fix solution (p8).

Stretch damp fabric taut over plastic-covered tackboard and pin down along all sides. Let dry.

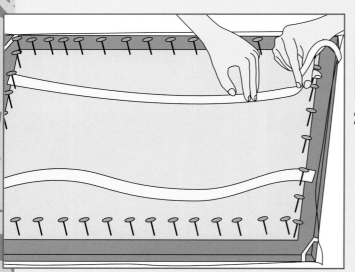

2 Lay down 1 in masking tape along length of fabric in 3 curved lines to make 4 sections. (Create the curves by holding down tape with one hand as you pull the tape in another direction.)

3 On cutting board lay down pieces of 2 in tape each 3 to 3-1/2 in long. With craft knife cut these into leaf-like shapes. Lift these shapes carefully from cutting board and press down onto fabric randomly on each side of the curved tape, *see* photograph. Press tape down firmly with back of spoon.

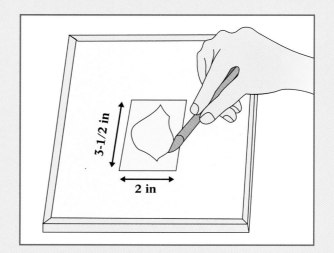

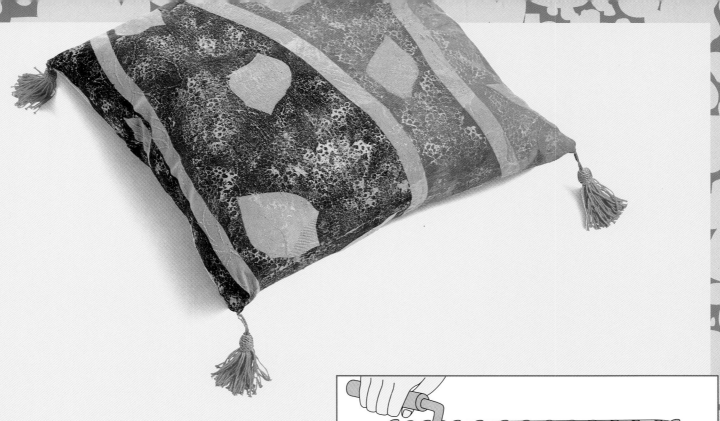

4 Mix 1 tin dye into 1/2 cup prepared paste for each color.

Pour each color dye paste in turn into paint tray and dip roller in lightly. Roller the dye paste onto the fabric, a different color for each section of fabric that is separated by the taped lines. It is all right to roller over the leaf shapes.

5 Cover with plastic sheet and leave overnight. Remove plastic and allow to air dry. Remove tape and wash and dry, as directed on p9.

Stretch fabric again on tackboard.

6 Pour metallic gold fabric paint into tray. Dip sponge into metallic gold paint. Dab off excess on paper towel. Lightly dab an all-over metallic gold pattern on the entire piece of fabric. Set the paint according to manufacturer's instructions.

7 Cut the fabric into 2 equal pieces and sew into a pillow cover.

Sew tassels onto each corner, if desired.

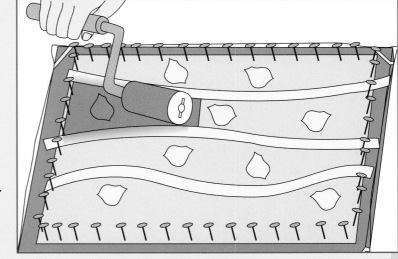

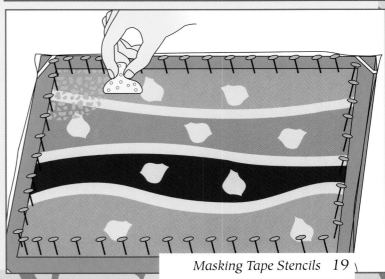

Decorated Containers

MATERIALS

newspapers • painter's mask • 8-in-diameter metal container with lid • 1 can aluminum rustproof spray paint • 1 yd lace trim, 2-1/2 in wide • scissors • repositionable spray adhesive • 1 can pink acrylic enamel spray paint • paper doily (slightly smaller than container lid)

1 Prepare work surface (p6) outside or in a well-ventilated space. Cover work surface and nearby surfaces with newspapers.

2 Wearing painter's mask, spray metal container and lid with aluminum paint. Allow to dry. Repeat 2 more times.

Spray the lace with 1 coat of paint to stiffen. Allow to dry thoroughly.

3 Measure the lace trim around the outside of the tin, as shown, with a 1/4 in overlap. Cut away any excess. Coat one side of lace lightly with repositionable spray adhesive. Place the lace, tacky side down, in a border around the bottom section of the container.

4 Using pink enamel spray paint, spray through the lace and above and below it so that all visible surfaces are colored. Allow to dry. Repeat 2 times. Carefully peel off lace.

5 Spray adhesive lightly on the back of the doily. Center it on top of the lid. Spray pink paint on exposed surfaces through the openings and on the edge. Allow to dry. Repeat 2 times. Lift off the doily.

Decorate another container with blue paint using only lace on sides and lid.

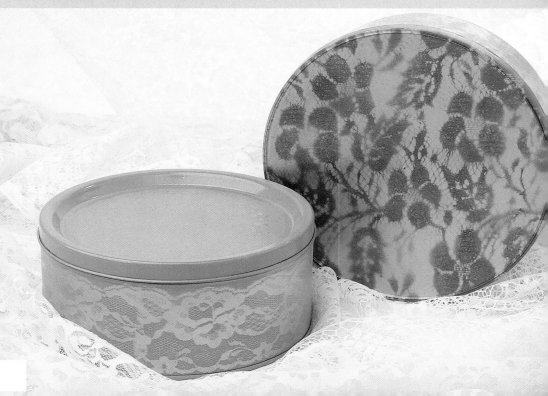

1 Strengthen the paper for making the stencil (p10).

2 To make pattern the right size to repeat 4 times around the pot, measure the circumference of the pot and divide by 4. Allow about 1/2 in for a small space between each pattern. This will give the width of the cut pattern (4 in for the project shown). Use a larger square of paper to allow for borders around the pattern.

3 Fold the paper into quarters and then in triangles and trace (p9) and cut the pattern, as shown. Unfold. Press pattern flat with an iron at medium setting.

 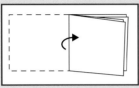 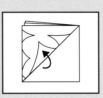 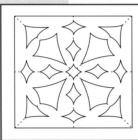

4 Spray entire flower pot with red acrylic paint. Let dry. Repeat twice.

5 Spray one side of the stencil with repositionable spray adhesive. Center the stencil against the side of the pot and press to adhere.

6 Squeeze navy acrylic paint into paint tray. Dip in brush. Stipple (p11) navy paint through whole stencil. Let dry.

7 Squeeze light blue acrylic paint into paint tray and stipple light blue paint only in the center sections of stencil, over navy, as shown. Remove stencil carefully.

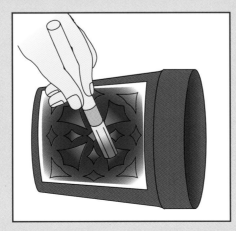

8 Apply stencil again on direct opposite side of pot. The other 2 stencil patterns are centered between the first 2.

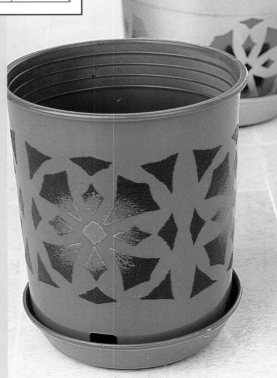

Wastebasket

MATERIALS

bond paper, 6 in x 10 in · clear acrylic varnish · small brush · tracing paper · pencil · geometric pattern (p65) · small sharp scissors · iron · repositionable spray adhesive · 1 plastic wastepaper basket, 8 in x 8 in x 12 in · 1 small tube each of acrylic paint—turquoise, rose · paint tray · stencil brushes, 3/8 in and 3/16 in wide

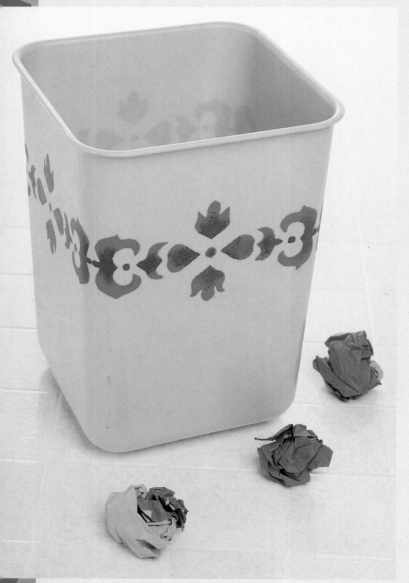

1 Strengthen the paper for making the stencil (p10).

2 Fold paper in half and in half again.

Trace (p9) and cut the pattern, as shown. Unfold.

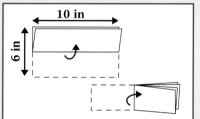

3 Press pattern flat with an iron at medium setting.

4 Spray stencil lightly on one side with repositionable spray adhesive.

Make 2 dots with pencil 6 in apart and 6 in from bottom of wastebasket, as shown. Align bottom of stencil with these dots and press on.

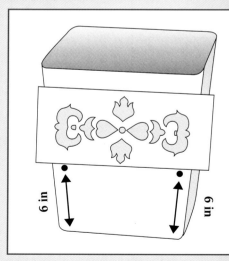

5 Squeeze turquoise and rose paint in paint tray. Dip 3/8 in brush in turquoise paint and fill in entire pattern. Allow to dry a few minutes.

Dip 3/16 in brush in rose paint. Stipple (p11) over turquoise in central sections of stencil. *See* photo.

6 Carefully remove stencil. Allow to dry. Repeat on other sides of baske

Lamp Shade

MATERIALS

bond paper, 8-1/2 in x 7-1/2 in • clear acrylic varnish • small brush • geometric pattern (p66) • tracing paper • pencil • scissors • iron • repositionable spray adhesive • rose fabric-covered lamp shade, 8 in high • 1 small bottle each of acrylic fabric paint—dark blue, pale pink • paint tray • stencil brushes, 3/8 in and 3/16 in wide • 1 squeeze bottle rose pearlized acrylic dimensional paint

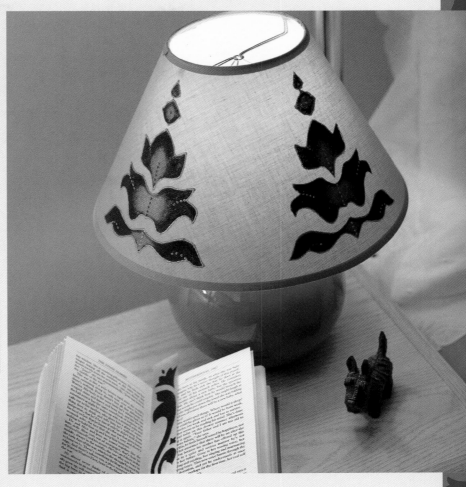

1 Strengthen the paper for making the stencil (p10).

2 Fold paper in half lengthwise and trace (p9) pattern along center fold and cut out. Unfold.

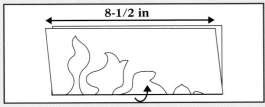

8-1/2 in

3 Press pattern flat with an iron at medium setting.

4 Lightly coat back of stencil with repositionable spray adhesive. Position stencil straight up and down on side of lamp shade.

5 Pour dark blue paint in paint tray. Dip in brush and stipple (p11) on pattern. Allow to dry a few minutes.

 Pour pale pink paint in paint tray. Dip in clean brush and stipple over blue paint in middle section of pattern. Allow to dry.

6 Move pattern to opposite side and repeat. Then stencil 2 more patterns evenly spaced between the first two. (4 stencil patterns encircle the shade.)

7 When dry, squeeze rose pearlized dimensional paint to outline pattern and create beaded enhancements (*see* photo).

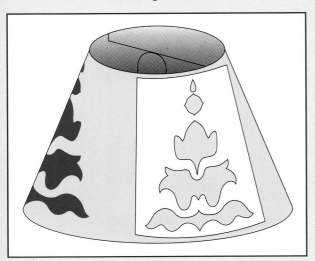

Umbrella

MATERIALS

bond paper, 5 in x 9 in • clear acrylic varnish • small brush • tracing paper • pencil • geometric pattern (p67) • ruler • scissors • iron • repositionable spray adhesive • light gray umbrella • plastic-covered ironing board • straight pins • low chair or stool • 1 small bottle each of fabric paint—green, metallic orchid • paint tray • stencil brushes, 3/8 in and 3/16 in wide

1 Strengthen the paper for making the stencil (p10).

2 Fold paper in half lengthwise, then make the next fold crosswise, 1-3/4 in from the end.

Trace (p9) the pattern on the short folded end first, then cut and unfold, as shown. Trace the lengthwise pattern along the center fold and cut out. Unfold.

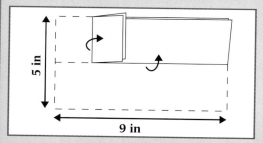

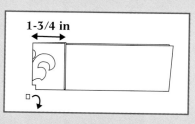

3 Press patterns with an iron at medium setting.

4 Open the umbrella and place one section over the narrow end of the plastic-covered ironing board. Hold in place with pins, and rest other side of umbrella on low chair or stool.

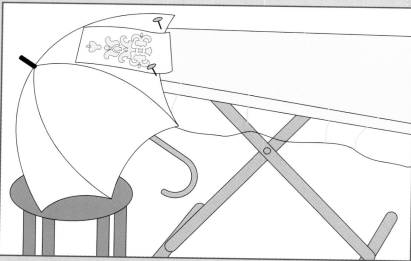

5 Spray stencil lightly on one side with repositionable spray adhesive. Position the stencil on each section of the umbrella in turn, as shown, allowing the same distance from the umbrella's edge each time.

6 Pour paint in tray. Using the larger stencil brush, stipple (p11) green paint through the entire stencil. Allow to dry a few minutes.

Dip other stencil brush in orchid paint and stipple on top of green paint in central sections of stencil. Allow each section to dry before moving to the next section of the umbrella.

Paint every other section with this color combination. Reverse colors for alternate sections: orchid base with green stippled on top of orchid in central sections of stencil.

Pillow Case & Sheet

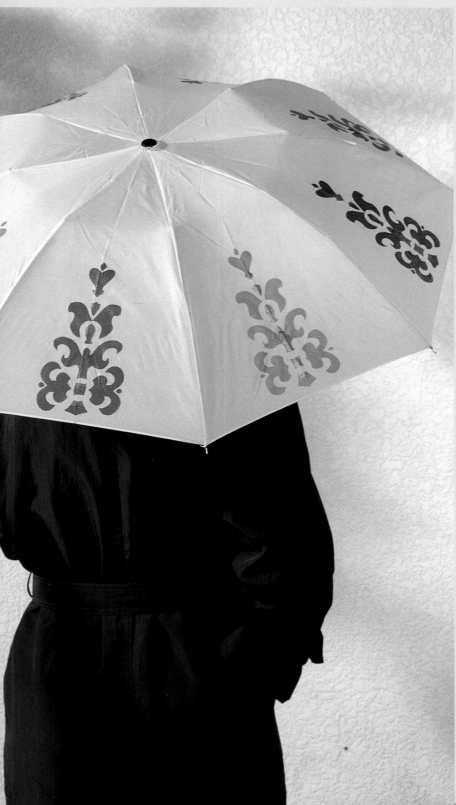

MATERIALS
bond paper, 5 in x 15 in • clear acrylic varnish • small brush • ruler • pencil • tracing paper • bird pattern (p66) • craft knife • cutting board • iron • repositionable spray adhesive • prewashed white pillow case and single sheet • newspaper • tackboard (p6) • plastic sheet • straight pins • 1 small bottle each of fabric paint—dark aqua, light aqua, orange • paint tray • stencil brushes, 3/8 in and 3/16 in wide

1　Strengthen the bond paper for making the stencil (p10).

2　Fold paper in half. Then fold again at a point 3-1/2 in from the center, as shown.

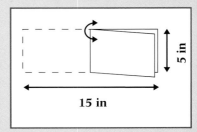

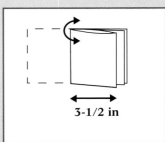

3 Trace pattern (p9) onto one of the center sections allowing 1/8 in between design and folded edge.

4 Cut the design through all 4 layers of the paper, using a sharp craft knife on a cutting board. Unfold. Press pattern flat with an iron at medium setting. There are 4 birds in this stencil.

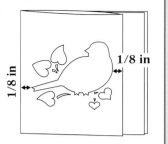

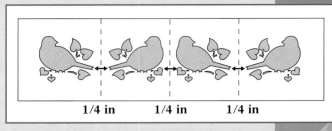

5 Place a sheet of newspaper into the open end of pillow case to prevent the paint from soaking through. Stretch the pillow case taut and pin down to a plastic-covered tackboard.

6 Lightly coat one side of stencil with repositionable spray adhesive. Center stencil along the hemmed edge, as shown.

7 Pour fabric paint in paint tray. Using 3/8 in brush, stipple (p11) dark aqua on the body, tail, and head of bird. Using 3/16 in brush and light aqua paint, stipple stems and leaves. Using clean 3/8 in brush, stipple orange paint on birds' breasts fading it into the dark aqua. Allow to dry.

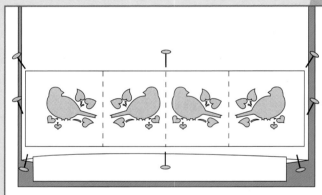

Set fabric colors according to manufacturer's instructions.

8 Mark center of top edge of sheet with a straight pin.

Stretch top edge of sheet taut on plastic-covered tackboard, with center of sheet in the center of the board. Pin in place.

9 Position bird stencil along top hem of sheet, with its center matched to sheet center.

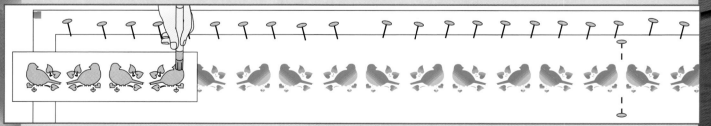

10 Stipple fabric paint on pattern as in pillow case above. When dry, move the sheet to right and left on tackboard, as required, to stencil 2 more full patterns, one on each side of the central 4-bird pattern. (Diagram shows half of the sheet.) Stencil 3 of the 4 birds in the stencil at each far side, as shown.

11 Set fabric colors according to manufacturer's instructions.

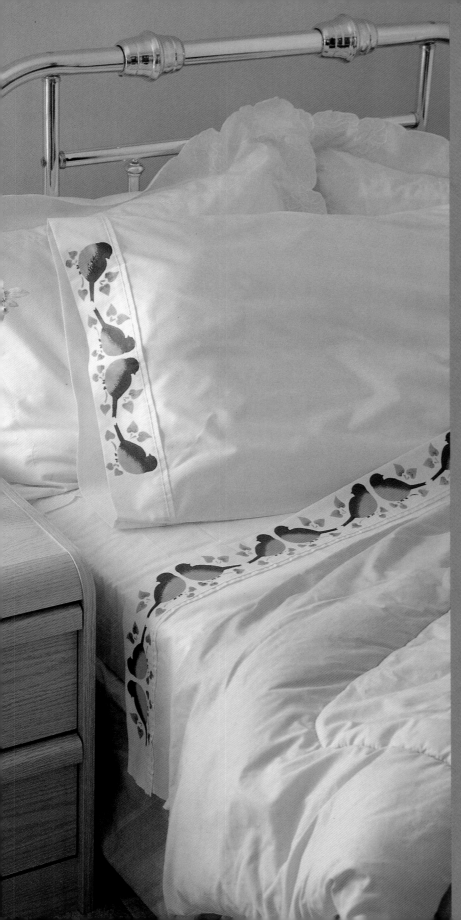

Bookmark

MATERIALS

clear mylar, 3 in x 11 in · stencil patterns (p68) · pencil · craft knife · repositionable spray adhesive · newspaper · 9 in red flocked ribbon, 1-3/8 in wide · small bottle navy acrylic paint · paint tray · stencil brush, 3/16 in wide

1 Make mylar stencil (p10) using the pattern on p68.

2 Lightly coat back of stencil with repositionable spray adhesive.

3 Spread newspaper on work surface. Lay ribbon on newspaper. Place stencil over ribbon, being careful to position it centrally.

4 Pour paint into paint tray. Using stencil brush, stipple (p11) paint through stencil pattern. Lift stencil. Allow to dry.

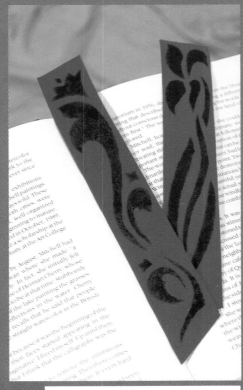

Ribbon Hanging

MATERIALS

clear mylar, 13 in x 6 in · craft knife · pattern (p68) · 1 yd pink fabric ribbon, 4 in wide · plastic sheet · tackboard (p6) · straight pins · waterproof fine-tipped felt marker · repositionable spray adhesive · 1 small bottle each of acrylic fabric paint—green, fuschia · paint tray · 2 stencil brushes, 3/8 in wide · fabric glue · small handsaw · 3/8 in wooden dowel , 1 ft long · fine sandpaper · flat paint brush, 1/2 in wide · 6-1/2 yds green ribbon, 1/4 in wide

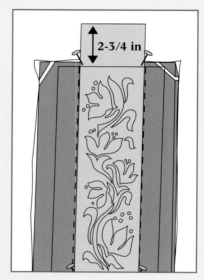

1 Make mylar stencil (p10) using pattern on p68.

2 Stretch ribbon taut on plastic-covered tackboard and pin down securely top and bottom.

3 Center cut stencil over ribbon and mark edges of ribbon on stencil using the felt marker.

4 Lightly spray back of stencil with repositionable spray adhesive. Place stencil on ribbon so pattern is 2-3/4 in down from top. Use felt pen lines to register stencil. Press down.

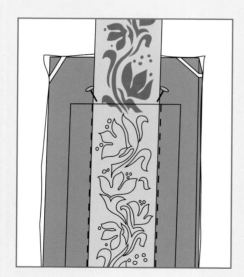

5 Pour green and fuschia paint into paint tray.

6 Using stencil brushes, stipple (p11) paint through stencil pattern. Paint flowers fuschia, and leaves and dots green, shading green into bottom section of flowers. Lift stencil carefully. Allow to dry.

7 Reposition stencil below first print, lining up the side felt marker lines with ribbon edge, and matching the top leaf form with the bottom of the stem in the first printed pattern, as shown.

Repeat painting procedure. Print one more pattern below second. Allow to dry.

8 Using small handsaw, cut 2 pieces of dowel— one 5 in long, the other 4-1/2 in long. Sandpaper ends of dowel.

9 Using flat paint brush, coat dowels with fuschia paint. Allow to dry.

10 Roll the top and bottom ends of the ribbon around the dowelling (5 in dowel at top, and 4-1/2 in dowel at bottom), and fasten with fabric glue.

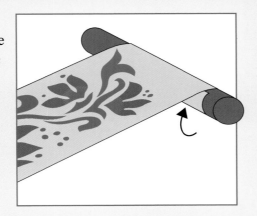

11 Cut green ribbon into 3 pieces—2 pieces in 2 yd lengths, 1 piece in 2-1/2 yd length.

Tie each 2 yd length in a bow on each side of top dowel, leaving 2 long streamers on each side, as shown.

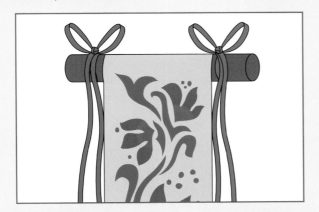

12 Tie 2-1/2 yd length to dowel with a knot on the outside of each bow, leaving a small loop in center for hanging, as shown, and 2 long streamers, one on each side. Hang.

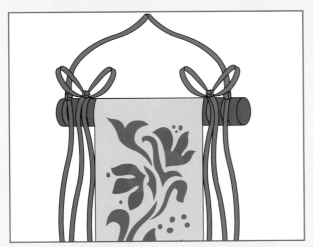

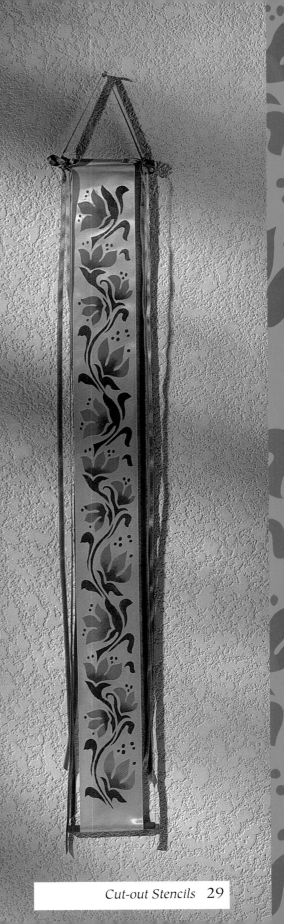

Switch Plate

MATERIALS
newspaper · 1 small bottle each of acrylic paint—navy, metallic gold · paint tray · flat paint brush, 1 in wide · wooden switch plate, 3-1/2 in x 6 in · clear mylar, 6 in x 8 in · craft knife · waterproof fine-tipped felt marker · pattern (p69) · repositionable spray adhesive · stencil brush, 3/16 in wide · clear acrylic varnish

1 Spread newspaper on work surface. Using flat paint brush and navy paint, coat entire surface of switch plate. Set aside to dry.

2 Make mylar stencil (p10) using pattern on p69.

3 Place stencil over switch plate and position pattern, as shown. (Avoid central holes cut for switch and screws.) With waterproof fine-tipped felt marker trace edges of plate on the stencil.

4 Lightly coat back of stencil with repositionable spray adhesive. Position stencil over switch plate, using felt marker lines for registration. Press down firmly.

5 Pour metallic gold paint in tray. Using stencil brush, stipple (p11) metallic gold through openings of stencil onto switch plate. Remove stencil. Allow to dry.

6 Apply 3 coats of acrylic varnish. Allow switch plate to dry between coats.

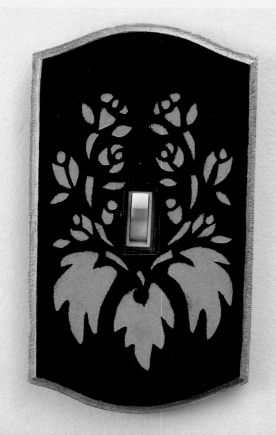

Rock Painting Paperweights

Select as many rocks as you want for paperweights. Rocks can be in various sizes.

MATERIALS
clear mylar, 4 in x 12 in · moose, geese, tree, sun patterns (p69) · waterproof fine-tipped felt marker · craft knife · repositionable spray adhesive · smooth rocks (found at aquarium supply stores) · 1 small tube each of acrylic paint—red, black, copper · paint tray · stencil brush, 3/16 in wide

1 Make mylar stencils (p10) using patterns on p69. Use one stencil pattern or combine patterns to make a scene, depending on size of rock.

2 Lightly coat back of the stencils with repositionable spray adhesive. Adhere to rock.

3 Squeeze black, copper, and red paints in paint tray. Using brush, stipple (p11) black and copper paint through geese, sun, tree, moose, and stencils. Use red or copper paint for sun. Remove stencils. Allow to dry.

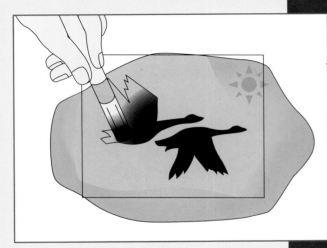

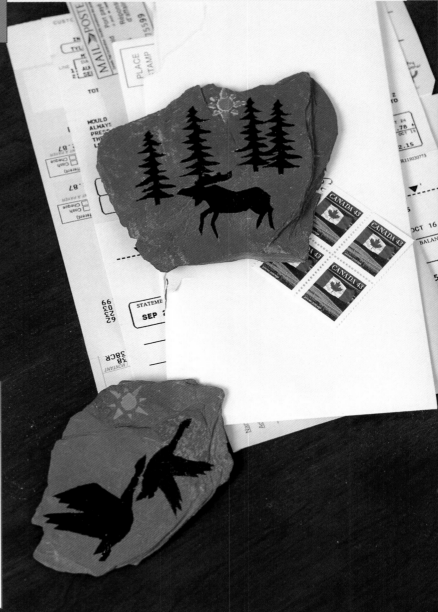

Trinket Box

MATERIALS

small unpainted wooden box with lid (purchase at craft store) · fine sandpaper · clean cloth · small bottle or tube each of acrylic paint—dark sea-green, red, orange, yellow, leaf green, turquoise, coral · paint tray · flat brush, 1/2 in wide · clear mylar, 5 in x 7 in · craft knife · geometric pattern (p70) · waterproof fine-tipped felt marker · repositionable spray adhesive · 5 stencil brushes, 3/16 in wide · masking tape · 1 squeeze bottle pearlescent turquoise acrylic dimensional paint · clear acrylic varnish

1 Sand all sides of the box until smooth. Wipe with a clean cloth.

2 Pour dark sea-green paint in paint tray. Dip flat brush in paint and coat outside and interior of box. Allow to dry.

3 Make the stencil (p10) using the pattern on p70.

4 Lightly coat the stencil back with repositionable spray adhesive and position it carefully in the center of the box lid. Press down firmly.

5 Pour or squeeze red, orange, yellow, leaf green, and turquoise paints in the tray. Use a clean, dry stencil brush for each color. Paint the flowers red, yellow, and orange, and the leaf forms green and turquoise, *see* photo. Carefully lift the stencil. Allow to dry thoroughly.

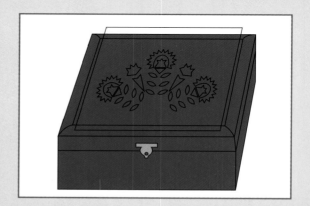

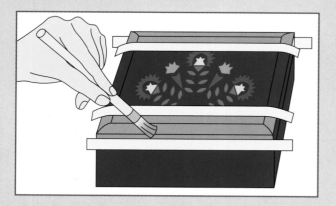

6 Using masking tape, mask off lines 1/2 in apart around the edges of the box lid, starting with opposite sides, as shown.

Dip clean flat brush in coral acrylic paint and paint the 1/2-in-wide space between the tape lines. Lift the tape. Allow to dry thoroughly.

Tape the other 2 opposite sides and paint the space between the 2 lines of tape with coral.

7 Lay down 2 strips of tape 3/4 in apart along the 4 sides of the box, above and below the box opening, as shown.

Paint the space between the tapes turquoise. Lift tape carefully and allow paint to dry.

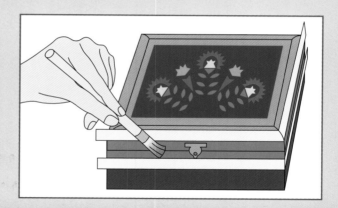

8 Using pearlescent turquoise dimensional paint, apply dots of raised color around the top edge of the painted coral edging. Allow to dry.

9 Using a clean paint brush, apply clear acrylic varnish to all surfaces.

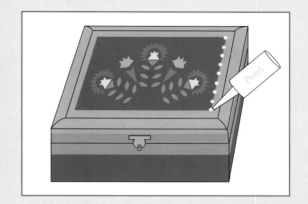

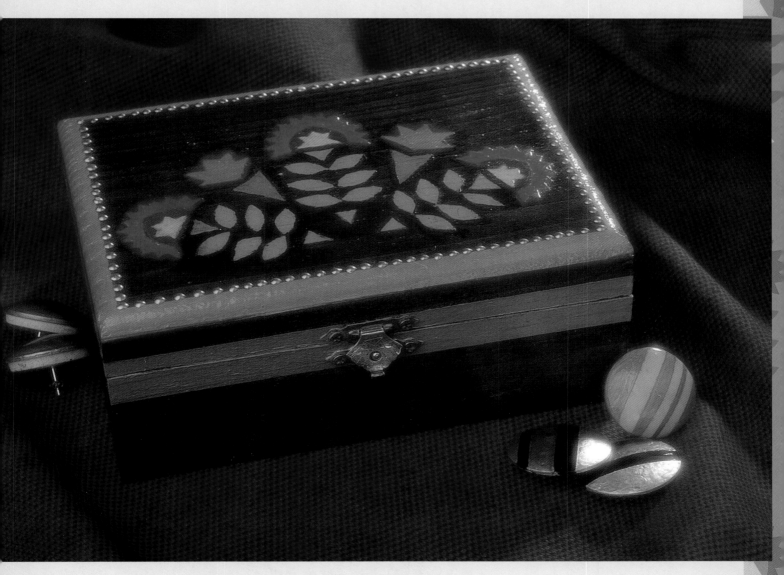

Napkin Rings

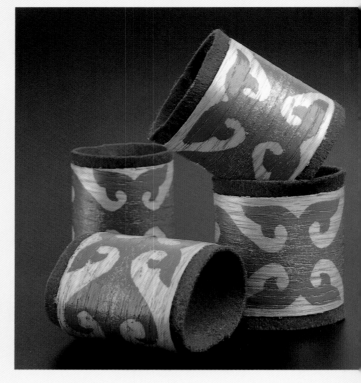

Wood veneers are available in varying widths at most lumber stores. They offer an excellent surface for stencilled projects, and cut easily with a craft knife or scissors.

MATERIALS

clear mylar, 6-1/2 in x 3 in · geometric pattern (p70) · waterproof fine-tipped felt marker · craft knife · 5 ft flexible wood veneer, 2 in wide · pencil · right angle · sharp scissors · repositionable spray adhesive · 1 small bottle each of acrylic paint—turquoise, metallic gold · paint tray · stencil brush, 3/8 in wide · sponge · 4 ft turquoise felt, 2-1/2 in wide · fabric glue · wood glue · 16 clothespins

1. Make stencil (p10) using pattern on p70.

2. Mark veneer with a line at right angles to the edge, every 6-1/2 in. Cut with scissors.

3. Place transparent stencil centered along length of veneer section so pattern is 3/4 in from one end of veneer. With felt marker draw a line on stencil to mark this end. Mark the sides of the veneer as well.

6-1/2 in

4. Lightly coat back of stencil with repositionable spray adhesive. Position stencil along the length of veneer strip, lining up the registration marks with one end of the veneer and the sides. Press into place.

3/4 in

5. Pour paint into tray. Using stencil brush, apply turquoise paint through stencil pattern.

 Using the sponge, dip lightly into metallic gold acrylic paint and dab highlights in central areas of design over the turquoise. Remove stencil and allow paint to dry.

6. Cut turquoise felt into 8 pieces, 6 in by 2-1/2 in.

7 Spread fabric glue onto back of veneer strip. Position veneer on felt, even at one end and centered along felt strip with 1/4 in felt overlap along each side, as shown. There will be 1/2 in of unbacked veneer at the other end.

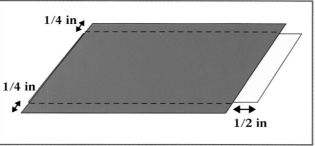

8 Spread wood glue on unbacked inside end of veneer. Gently coax veneer into a circle. Overlap glued end over other end. Press together firmly. Hold in place with 2 clothespins until dry.

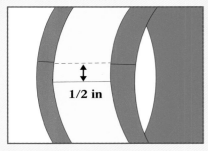

9 Repeat stencilling, gluing, and clamping steps for each piece of veneer and felt.

10 Finish with clear acrylic varnish.

Leatherette works well in place of wood veneer.

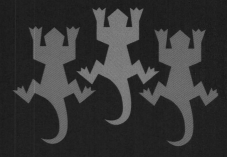

Gift Wrap

MATERIALS
newspaper · 1 pt each of latex paint—gray, pink, orange, black, white · 2 paint trays · 2 small sponge paint rollers · iron · ruler · 1 piece of styrofoam, 6 in square · 4 pieces of styrofoam, 5 in square · bubble wrap, 6 in square · craft knife · fabric glue · 2 sponges, 1/2 in thick · waterproof fine-tipped felt marker · scissors · 1 yd soft cord, 1/4 in thick

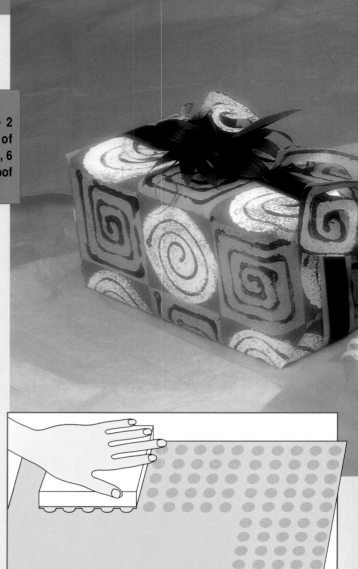

1. Spread newspaper double sheet on top of the work surface (p6).

2. Pour gray and pink paint into separate paint trays. Dip paint roller into gray paint and coat one side of 2 double sheets of newspaper. This is the background color. Lay aside to dry. Make a third using pink as the background color.
 If dried edges roll up, press with an iron on low setting on the unpainted side. The 3 sheets are now ready for printing.

BUBBLE WRAP STAMP

1. Put fabric glue on one side of 6-in-square styrofoam and adhere bubble wrap to it, bubble side up to make stamp (p12). Allow to dry.

2. Dip paint roller into gray paint and roll over bubble surface on stamp. Print stamp in solid rows on pink-painted newspaper to form an all-over pattern. Replenish paint on stamp as needed. Allow to dry.

SPONGE STAMP

1. Using a waterproof fine-tipped felt pen, draw a 4-in-diameter circle and a 4 in square on sponges. Cut out with scissors.

2. Measure a 4-in-diameter circle and a 4 in square on styrofoam. Cut out with craft knife. Put fabric glue on one side of styrofoam circle and square and press on matching sponge circle and square. Allow to dry.

3. Pour black and orange paint in 2 paint trays. Dip in sponge paint rollers and apply orange to the circle and black to the square stamps. Alternate square and circle stamps to make rows on gray-painted newspaper, as shown.

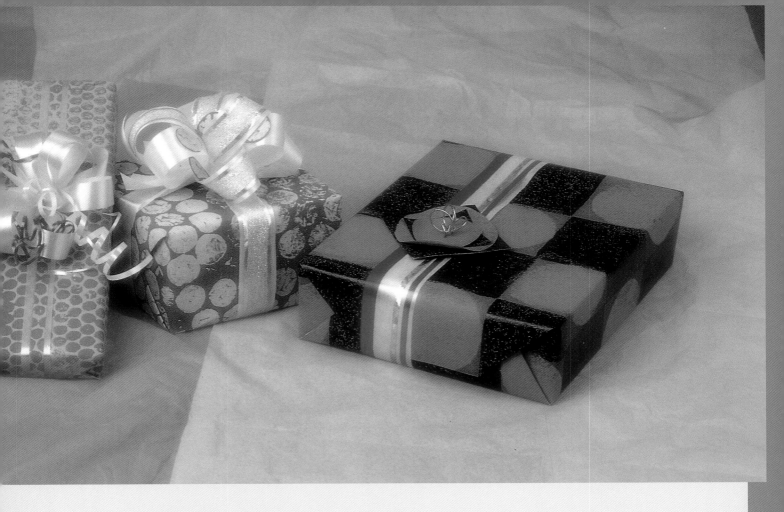

CORD STAMP

1 Clean the square and circle sponge stamps above. Coat the square sponge stamp with pink paint and the circle sponge stamp with white paint. Alternate square and circle stamps to make rows on gray-painted newspaper, as shown. Allow to dry.

2 Trace a 4-in-diameter circle on a piece of styrofoam and cut out with craft knife. Draw a spiral on the styrofoam with a felt pen.

3 Cut the 1 yd cord in half with scissors. Using fabric glue, adhere the cord along the spiral pattern on the styrofoam. Allow glue to dry.

4 Repeat using a 4 in square of styrofoam as the base and a squared off spiral pattern, as shown.

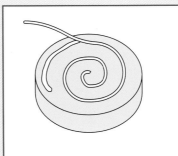
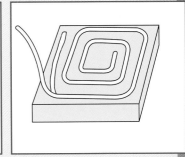

5 Pour black paint in a paint tray. Using a roller, apply paint to the 2 cord surfaces. Print black square cord patterns in the pink squares and black circle cord patterns in the white circles.

Coasters

MATERIALS

4-in-diameter circle of styrofoam, 1/2 in thick · embossed wallpaper scraps · pencil · scissors · fabric glue · tackboard (p6) · straight pins · 1/3 yd white medium-weight fabric · 1 tube of red acrylic paint · paint tray · small paint roller · 1/3 yd red felt · clear acrylic varnish · small brush

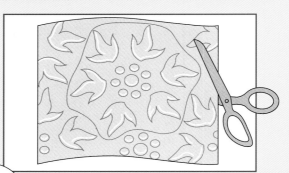

1 Select a section of embossed wallpaper that will fit into the 4-in-diameter circle of styrofoam. Draw the circle on the wallpaper pattern and cut out with scissors.

2 Using fabric glue, adhere wallpaper to styrofoam. Allow to dry.

3 Stretch white fabric taut on the tackboard and pin down.

4 Squeeze red paint into paint tray. Dip in roller and coat surface of stamp. Test on scrap of paper to determine amount of pressure to use. Press stamp on white fabric. Apply paint and stamp fabric as many times as the number of coasters desired. Allow to dry.

5 Carefully cut out circles with scissors.

6 Cut out a slightly larger circle from the red felt (4-1/2 in diameter). Using fabric glue, center and glue stamped circles to felt circles. Allow to dry.

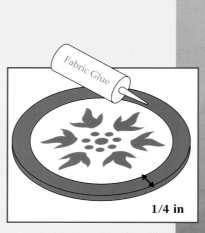

1/4 in

7 Coat stamped fabric circle with acrylic varnish.

Combining Small Stamps

The following 5 projects make use of a collection of small stamps. NOTE Colors of stamps can be varied.

MATERIALS TO MAKE THE **STAMPS**

bond paper · tracing paper ·pencil · small stamp patterns (pp71–2) ·12 pieces of styrofoam and heavy felt, each 3 in square · scissors · craft knife · fabric glue

1 Make stamps (p12) using patterns on pp71–2. Choose stamps you need for projects on pp 39–41.

MATERIALS FOR A **CAP**

2 flower and 1 leaf stamps (*see* above) · purchased blue cap · tackboard (p6) · newspaper · straight pins · 1 bottle each of fabric paint—light pink, rose, green · paint tray · 2 flat paint brushes, 1 in wide · cotton swab sticks · 1 squeeze bottle metallic gold dimensional fabric paint

1 On newspaper-covered tackboard flatten out front upper hat section and pin down.

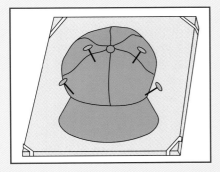

2 Pour pink, rose, and green paint into paint tray.

Dip brush in pink paint and coat smaller flower stamp. Dip brush in rose paint and coat center sections of flower on top of light pink paint. Print this flower shape in top section of cap.

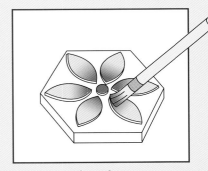

3 Using cotton swab stick, dip into green paint and make green center for flower. Allow to dry.

4 Outline and detail the flower with metallic gold dimensional paint. Allow to dry.

5 Unpin cap from tackboard and lay the brim flat on the work surface.

6 Repeat printing process with same colors on second flower stamp. Print on brim.

7 Dip another brush in green paint and coat the leaf stamp. Stamp 2 leaves on brim of hat, *see* photo.

8 Detail with metallic gold dimensional paint. Allow to dry.

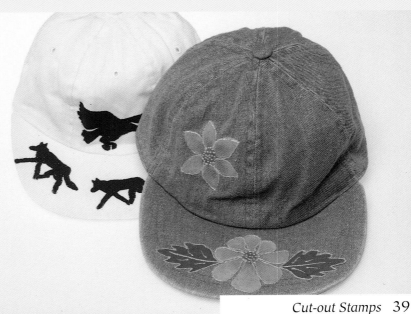

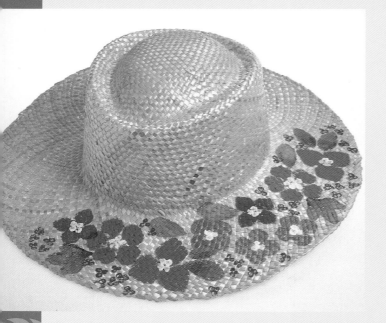

MATERIALS FOR A STRAW HAT

flower and leaf pattern stamps, *see* p39 · purchased plain straw hat with brim · newspaper · straight pins · 1 small tube each acrylic paint—turquoise, carmine, coral, purple, white · paint tray · 4 small paint brushes · cotton swab sticks

1 Place hat, with brim flat, onto newspaper-covered work surface. Pin in place.

2 Pour out paint colors into tray.

 Using a brush for each color, coat the surface of the flower and leaf stamps following colors in photo. Print around hat brim.

3 Using a cotton swab stick, dip the end into carmine paint and print small clusters of 3 dots in the spaces between larger flowers.

4 Using another cotton swab stick, dip into white paint and make centers for flowers. Allow to dry.

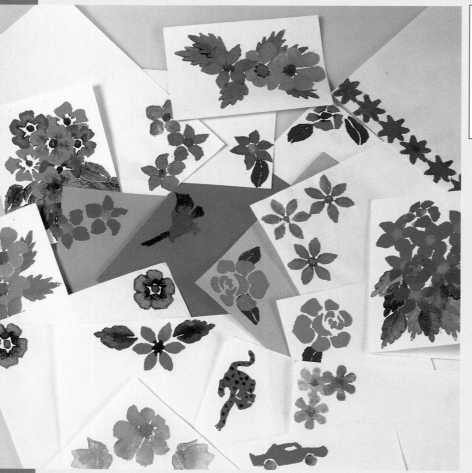

MATERIALS FOR NOTE PAPER

flower, leaf, leopard, eagle, car pattern stamps, *see* p39 · plain writing paper · newspapers · 1 small tube each of acrylic paints—pink, rose, aqua, dark blue, green, purple, metallic gold, orange, brown, white · paint tray · 4 small paint brushes · cotton swab stick

1 Place each sheet of writing paper to be decorated on a flat newspaper-covered work surface.

2 Squeeze each color of paint into separate areas of paint tray.

 Using a clean, dry brush for each color, coat the surfaces of the stamps, following colors in photo.

3 Print designs on paper in areas that will not interfere with written message.

4 Using the end of a cotton swab stick dipped into contrasting paint, add centers to flowers. Allow to dry.

MATERIALS FOR BOTTLES

flower and leaf pattern stamps, *see* p39 · 1 tube each of acrylic paint—red, aqua, yellow · paint tray · selection of colored wine bottles · 4 small paint brushes · cotton swab sticks · corks

1 Squeeze paints into areas on tray. Using a small paint brush for each color, coat the flower stamps and leaf stamps with paint, following colors in photo.

2 Holding the bottle by the top, stamp flower and leaf patterns randomly on lower section of bottle, as shown. Roll each stamp gently while printing to accommodate the curve of the bottle.

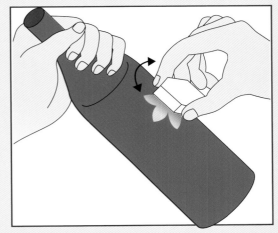

3 Using the end of cotton swab sticks dipped into white and yellow paint, add centers to flowers. Allow to dry.

4 To use bottles for storage, insert a cork in each one.

MATERIALS FOR CANDLES

flower and leaf pattern stamps, *see* p39 · 1 small tube each of acrylic paint—pink, purple, coral, carmine, blue, turquoise · paint tray · 1 each pink, yellow, and white wax candles · 4 small brushes · cotton swab sticks

1 Follow the instructions given for the Bottles above.

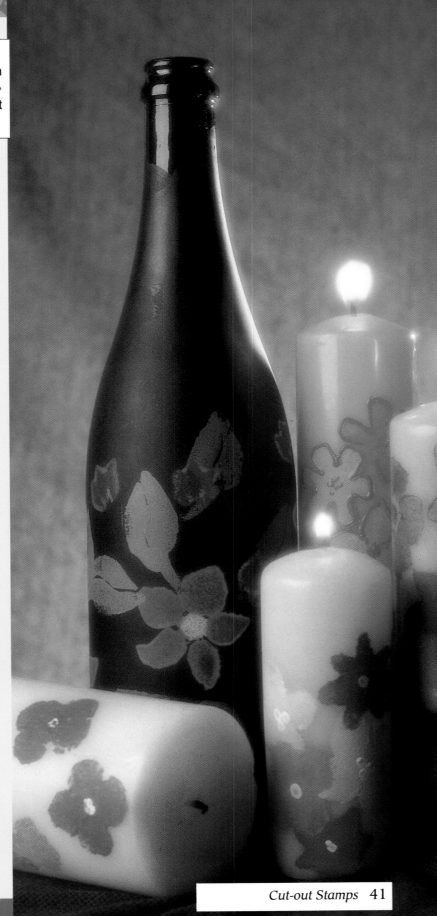

Matching Gift Wrap • Card • Ribbon

MATERIALS

sheet of bond paper • tracing paper • pencil • flower patterns (p72) • scissors • repositionable spray adhesive • 1 piece styrofoam and heavy felt, each 6 in square • craft knife • fabric glue • 1 pt each latex paint—green, pink, yellow, orange • 4 paint trays • 4 sponge rollers • white card stock, 4 in x 8 in • pink ribbon, 1-1/2 in wide • tackboard (p6) • straight pins

1 Paint a newspaper double sheet with green latex paint (p36).

2 Make 4 different flower stamps (p12) using the patterns on p72.

3 Pour pink, yellow, and orange paint in separate paint trays. Dip in sponge rollers and coat each flower stamp a different color.

4 Stamp flowers in a random pattern on green-painted newspaper.

5 Measure and score (*do not cut*) a line with a sharp point dividing the card stock in half, so that when folded, the card will be 4 in square. Lay card flat. Paint outside of card green to match the base color of the newspaper gift wrap. Allow to dry.

6 Stamp the colored surface with flowers to match the gift wrap paper.

7 Pin down a length of pink ribbon onto the tackboard.

8 Stamp the ribbon with smaller flower stamps to match the gift wrap. NOTE Paint and stamp the gift wrap, card, and ribbon at the same time for easy color matching.

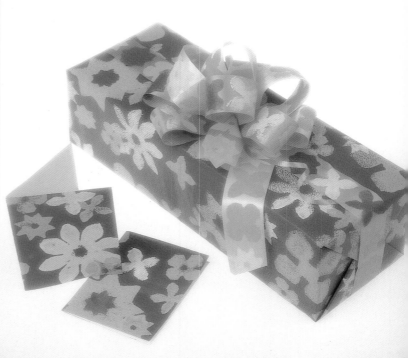

3-Ring Binder Cover

MATERIALS

tracing paper pencil cat and geometric patterns (p73) 2 pieces styrofoam and heavy felt, each 3 in x 6 in 1 piece styrofoam and heavy felt, each 1-1/2 in square fabric glue scissors craft knife 3-ring blue-gray binder, 9-1/2 in x 11-1/2 in chalk ruler 1 tube each of acrylic paint—magenta, pink paint tray 2 polyfoam brushes, 1 in wide 1 squeeze bottle metallic gold dimensional acrylic paint

1 Make 3 stamps (p12) using patterns on p73.

2 Measure and mark with chalk the center point of each side of the binder, as shown.

3 Pour magenta paint into paint tray. Dip polyfoam brush into paint and evenly coat the surface of the small square stamp.

4 Print small squares into each corner of the binder, back and front, on top and bottom of the spine, and one square centered on each long side and spine, as shown.

5 Fill in these sides with 2 squares, spaced evenly, on each side of the center square. Print 4 squares, spaced evenly, on top and bottom sides.

6 Pour pink paint into paint tray. Using polyfoam brush, evenly coat each cat stamp.

7 Print each cat pattern centered on each side of the cover, one cat on the front, the other on the back, as shown.

8 Using alternate cat patterns, stamp above and below the centered cats, as shown. Allow to dry.

9 Outline cat patterns and square block patterns with metallic gold dimensional paint. With metallic gold paint, draw eyes and whiskers on cats.

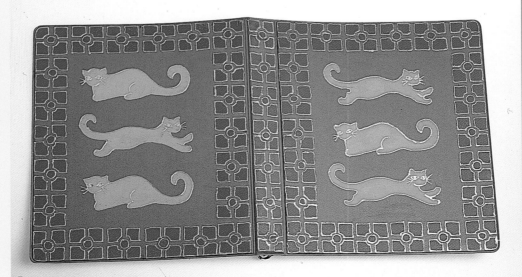

Floor Mat • Window Shade

MATERIALS

tracing paper • pencil • geometric pattern (p74) • piece of styrofoam and heavy felt, each 6 in square • fabric glue • cotton canvas, 32 in x 38 in • iron • newspaper • 1 qt blue-gray latex paint • paint tray • large paint roller • tackboard (p6) • straight pins • ruler • chalk • 1 pt black latex paint • small sponge roller • clear acrylic varathane • plain roller window shade

1 Make stamp (p12) using the pattern on p74.

2 Turn under 1/2 in on all sides of canvas. Press down with iron set at "cotton." Glue with fabric glue. Lay canvas on large newspaper-covered work surface.

3 Pour blue-gray paint into paint tray. Dip in large roller and coat surface of canvas. Allow to dry. Give canvas a second coat. Pin to tackboard. Allow to dry.

4 Measure and mark the center point of each side and center point of mat with chalk, as shown.

5 Pour black paint into clean paint tray. Dip in small roller. Coat surface of stamp.

6 Carefully stamp each corner of mat. Stamp a pattern on the center of each short side of the mat. Stamp the spaces in between, allowing 1/4 in between each block pattern, as shown. Print 2 patterns on each side of the center mark on the long side. Allow to dry.

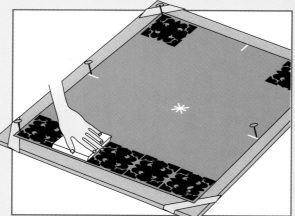

7 At the center point of mat, print 2 patterns one on each side of center point with 1/4 in space between, as shown. Allow to dry.

8 Using clean roller and paint tray, pour in clear acrylic varathane and apply 3 coats to mat, allowing time to dry between coats. Turn over and apply 2 coats to underside, allowing time to dry between coats. *If the floor mat is being used in a high traffic area you may wish to use a polyurethane coating.* Wait one week before using on a floor.

9 Unroll window shade completely and spread on large newspaper-covered work surface.

10 Pour blue-gray paint into paint tray. Dip in clean large roller and paint surface of shade. When dry turn over shade and paint the reverse side. Allow to dry.

11 On the front side, measure the center of the shade lengthwise and mark at intervals with chalk, as shown.

‡ 2 in

12 Rule and mark a line near and parallel to the bottom of the shade. Calculate how many 6 in block stamps will fit across this bottom line. If an uneven number, center the first print, as shown; if an even number, print one on each side of center mark.

13 Pour black paint into clean paint tray. Dip in small roller. Coat surface of stamp and carefully print a row of patterns across bottom of blind using chalk line as bottom guide, and allowing 1/4 in between each block, beginning at the center as directed above. Continue printing rows of pattern 2 in apart in this manner all the way up the blind, as shown.

14 Using clean roller and paint tray, pour in clear acrylic varathane and apply 2 coats to front and back sides of shade. Allow time to dry between coats. Allow a week for paint and varathane to fully cure before rolling up blind.

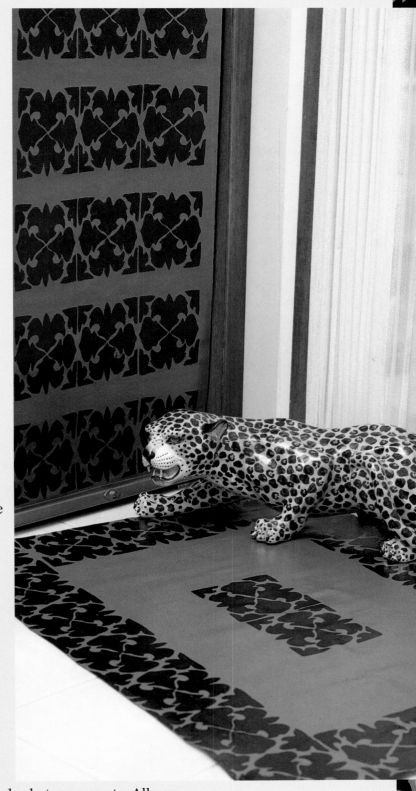

Wooden Trays

MATERIALS FOR TRAY WITH VINES
tracing paper · pencil · vine pattern (p75) · piece of styrofoam and heavy felt, each 9 in x 3 in · fabric glue · craft knife · scissors · wooden tray, 22 in x 11-1/2 in (purchased at secondhand store) · fine sandpaper · 1/2 pt each of latex paint—mahogany red, jade green · 2 paint trays · small sponge roller · ruler · chalk · 1 small squeeze bottle metallic gold acrylic dimensional paint · clear acrylic varnish · small paint brush

1. Make vine stamp (p12) using pattern on p75.

2. Sand tray. Clean thoroughly. Allow to dry.

 Pour mahogany red paint in paint tray. Dip in roller and coat all surfaces of tray. Allow to dry.

3. Measure and mark chalk lines 1 in from edges of tray on long sides.

4. Pour jade green paint in paint tray. Dip in clean roller and lightly coat surface of stamp.

5. Using chalk guidelines, stamp vine pattern in a line along one side of tray, overlapping slightly to make vine look continuous, as shown. Stamp vine pattern in opposite direction along other side of tray. Allow to dry.

6. Using squeeze bottle, carefully draw metallic gold outline around vine pattern. Allow to dry.

7. Apply 3 coats acrylic varnish with small paint brush, allowing each coat to dry completely.

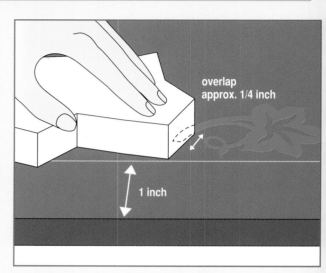

overlap approx. 1/4 inch

1 inch

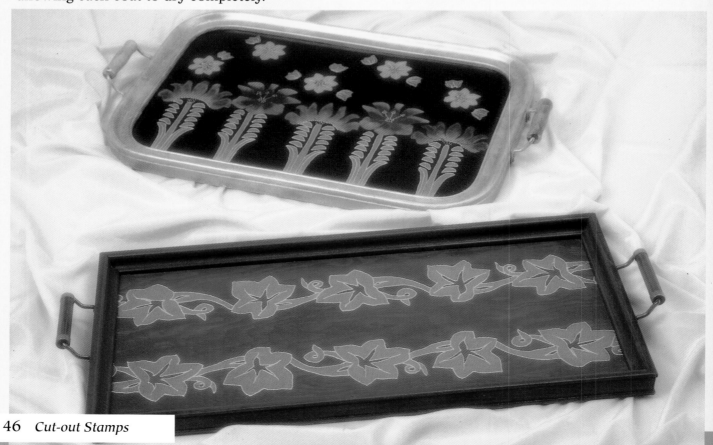

1 Make stamps (p12) using patterns on pp74–5.

2 Sand tray. Clean thoroughly. Allow to dry.

Pour black paint in paint tray. Dip in roller and paint all surfaces of tray. Allow to dry. Pour metallic gold paint in clean paint tray. Dip in sponge and carefully sponge onto frame of tray. *See* photo.

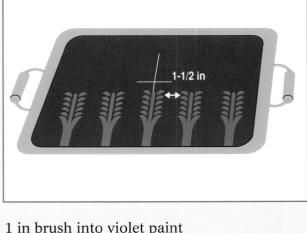

3 Measure and mark the center of tray with chalk.

4 Pour green paint into clean paint tray. Dip in roller and coat surface of leafy stalk stamp.

5 Press stamp first in lower center of tray and 2 more on each side spaced evenly along bottom of tray, allowing 1-1/2 in between, as shown. Allow to dry.

6 Pour violet and pink paint in clean paint tray. Dip 1 in brush into violet paint and coat both flower stamps. Dip another brush into pink paint and gently brush on stamp over violet color on the petal tips. Press stamps alternately on tray above each stalk pattern, as shown.

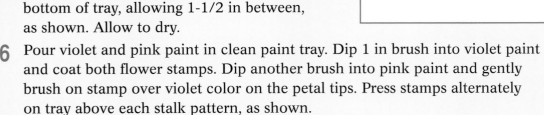

7 Dip brush into pink paint and coat small flower stamp. Print 5 small flower stamps above others. *See* photo.

8 Dip clean brush into green paint and coat small leaf stamp and print near small flowers. *See* photo. Allow to dry.

9 Using squeeze bottle, carefully draw metallic gold accents on flowers and leaves, as shown. Allow to dry.

10 Apply 3 coats acrylic varnish, drying between coats.

Place Mats

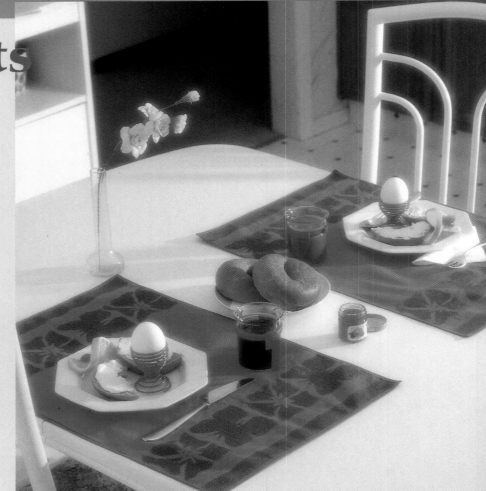

1. Make butterfly and flower stamps (p12) using patterns on p73.

2. Measure and cut fabric into 4 rectangles, 14 in x 21 in. Pin 1 rectangle to plastic-covered tackboard.

3. Press masking tape on each side of rectangle, 1-1/2 in from and parallel to outside edge, as shown.

4. Pour turquoise paint in tray. Dip in roller and color outside edges of red fabric up to masking tape. Remove tape. Allow to dry.

5. Dip roller into turquoise paint and cover butterfly and flower stamps. Press stamps onto red fabric 1 in from solid line. Alternate butterfly and flower stamps, one under the other, in rows down fabric on each side, as shown. Allow to dry.

6. Make the other 3 place mats in the same way.

 Set the fabric paint according to the manufacturer's instructions. Finish edges of place mats by sewing on turquoise bias tape on all 4 sides.

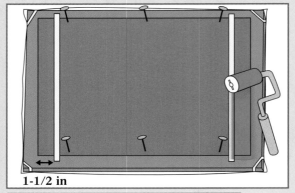

1-1/2 in

1 in

Table Runners

NOTE If you have only one tackboard, plan project for 2 days. Print the large piece on the first day and the 2 smaller pieces on the second day. Remember the dye paste colors lose their intensity after approximately 6 hours so prepare half of all dye mixtures on each day.

1 Make flower stamps (p12) using the patterns on p76.

2 Cut fabric in half lengthwise to make 2 pieces each 108 in x 18 in. Cut one of these in half again to make 2 pieces each 54 in x 18 in, for a total of 3 lengths of fabric. Trim 108 in piece of fabric to 96 in.

3 Soak fabric in fix solution (p8). Wring out. Stretch fabric taut on plastic-covered tackboards. Pin down every 1-1/2 in. Allow to dry.

4 Cut zigzag patterns lengthwise across center of each poster card to make 4 pieces. Using masking tape, join 2 pieces of card together matching zigzags, as shown. Repeat with other 2 pieces of card.

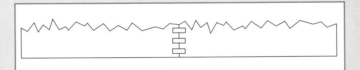

Lay down poster board centered along length of fabric with zigzag edge facing top edge, as shown.

5 Mix radiant pink dye with 2 cups prepared paste. Pour into paint tray. Using small sponge roller, apply dye onto top half section of fabric piece, rolling across zigzag edges of card stencil, as shown. Carefully pick up and move this card along the fabric as you print. Clean off edges with paper towel each time it is moved. Repeat with each piece of stretched fabric.

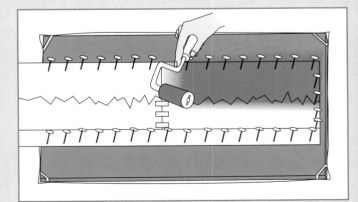

6 Cover with plastic for 3 hours. Uncover and let fabric air dry.

7 Mix French navy dye with 2 cups prepared paste. **NOTE** The quantity of dye to prepared paste is greater for intense colors. Pour into tray.

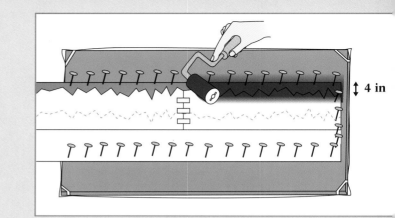

8 Place second piece of poster board 4 in from top edge along length of fabric over the pink printed section with zigzag edge towards top. Using roller, apply navy dye paste along exposed top edge as before, cleaning and moving card, as required.

9 Mix camellia dye with 1 cup prepared paste.

Stir 1/4 cup of the previously prepared radiant pink mixture into 1 cup prepared paste to make pale pink dye paste.

Stir 1/4 cup of previously prepared navy paste into 1 cup prepared paste to make pale blue paste.

10 Pour dye pastes into paint trays. Using sponge rollers, apply these mixtures to various flower stamps. Print along length of fabric in the undyed sections and extend up into the pink dyed sections. See photo. Overlap flower patterns according to taste. Stamp selected flower centers navy.

11 Cover with plastic. Leave overnight. Uncover, let air dry, and wash out (p9). Turn edges under and hem or fray edges, if desired.

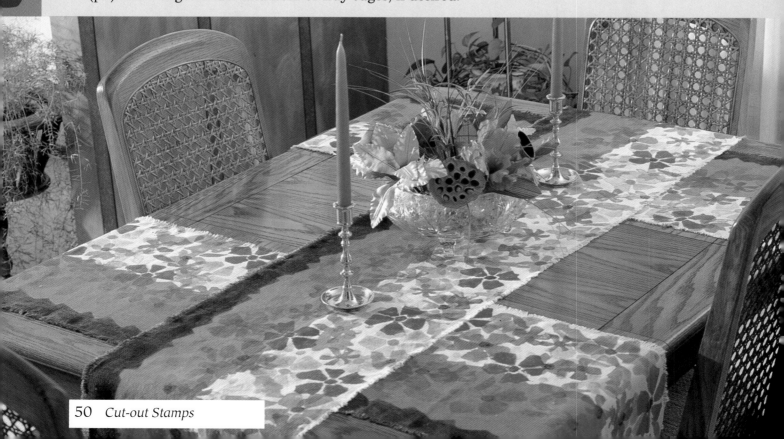

Shawl Scarf

MATERIALS

tracing paper · pencil · leaf pattern (p77) · piece of styrofoam and heavy felt, each 4-1/2 in x 8-1/2 in · scissors · craft knife · fabric glue · 45 in square of green prewashed silk · 1 pkg Dylon Cold Fix · plastic basin · yardstick · tackboard (p6) · 2 plastic sheets · straight pins · 3 tins French navy Dylon Cold Dye · 1 cup prepared paste (p8) · paint tray · sponge brush, 1 in wide · small sponge roller · large plastic sheet

1 Make leaf stamp (p12) using the pattern on p77. Rule a line along styrofoam back of stamp to provide a guideline parallel to baseline, as shown.

2 Soak silk in fix solution for 3 minutes (p8). Wring out. Stretch damp fabric on plastic-covered tackboard, pinning down every 1-1/2 in. Allow fabric to dry.

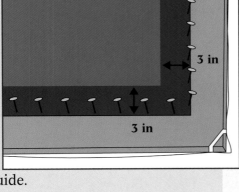

3 Lightly rule a 36 in square inside the edges, leaving a 3 in border all around.

4 Mix navy dye with dye paste thickener. Pour navy dye paste into the paint tray. Using sponge brush, paint a border around the scarf, using ruled lines as a guide.

5 Dip roller into dye paste and apply to leaf stamp. Print leaf stamp all around the scarf, using the painted border as a baseline. Repeat each print with slight overlap, as shown, keeping the ruled line on the back of the stamp parallel to the border. Make 6 prints on each side. Overlap the prints on the corners.

6 Cover with a plastic sheet overnight. Wash out (p9). Allow to dry. Hem all edges.

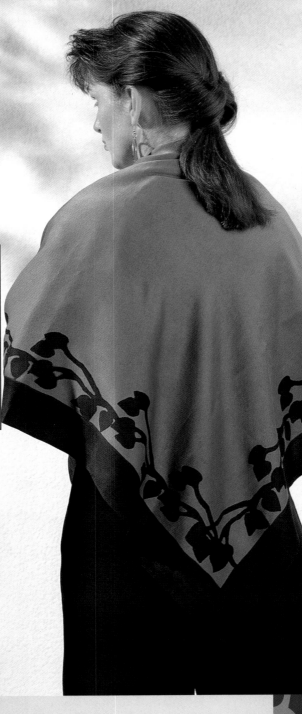

Fabric Lengths

MATERIALS FOR SHIRT FABRIC

tracing paper · pencil · leaf and cross patterns (p78) · pieces of styrofoam and heavy felt, 2 each 8-1/2 in x 6-1/2 in and 2 each 4-1/2 in square · fabric glue · scissors · craft knife · 2 yds prewashed pale blue heavy silk, 45 in wide · 2 pkgs Dylon Cold Fix · plastic basin · 2 large plastic sheets · tackboard (p6), 4 ft x 8 ft · straight pins · Dylon Cold Dye, 4 tins turquoise saga, 2 tins coral · 4 cups prepared paste (p8) · 2 plastic containers · tape measure · dressmaker's chalk · paint tray · 2 small sponge rollers

1. Make leaf and cross stamps (p12) using the patterns on p78. Rule intersecting lines centered on back of stamps, as shown.

2. Soak fabric in fix solution (p8). Wring out. Stretch fabric taut on plastic-covered tackboard. Pin down every 1-1/2 in. Let dry.

3. Using dressmaker's chalk, rule a graph on fabric surface as follows: Measure and mark fabric 3-1/4 in from left top and bottom edges of fabric, as shown. Continue along length of fabric marking a point every 6-1/2 in top and bottom. Join these marks with ruled chalk lines, as shown. Measure down from top corners and mark 4-1/4 in on each side, as shown. Continue down each side marking a point every 8-1/2 in. Join these marks with ruled chalk lines, as shown.

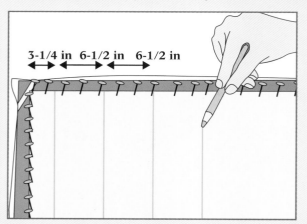

3-1/4 in 6-1/2 in 6-1/2 in

4-1/4 in 8-1/2 in 8-1/2 in

4. Mix 4 tins turquoise saga dye into 3 cups prepared paste. Pour into paint tray.

 Using sponge roller, coat leaf stamp each time you print, and stamp in rows on fabric. Position stamp so lines ruled on back of stamps are aligned with chalk lines, as shown.

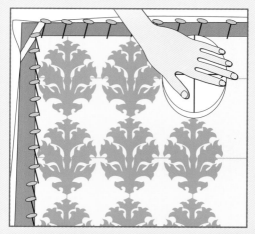

5. Mix 2 tins coral dye into 1 cup prepared paste. Pour into paint tray.

 Using clean roller, coat cross stamp each time you print. Stamp in center of spaces alternating between blue designs, as shown.

6. Cover with plastic. Leave overnight. Uncover, let dry, and wash out (p9). Fabric is ready for a pattern of your choice.

MATERIALS FOR SKIRT FABRIC

tracing paper · pencil · starburst and lily patterns (p79) · 2 pieces each styrofoam and heavy felt, each 6-1/2 in x 8 in · fabric glue · scissors · craft knife · 2-1/4 yds prewashed lime green heavy silk, 45 in wide · 2 pkgs Dylon Cold Fix · plastic basin · 2 large plastic sheets · tackboard (p6), 4 ft x 8 ft · straight pins · 3 tins each Dylon Cold Dye—Mexican red, turquoise saga · 4 cups prepared paste (p8) · 2 plastic containers · tape measure · dressmaker's chalk · paint tray · 2 small sponge rollers

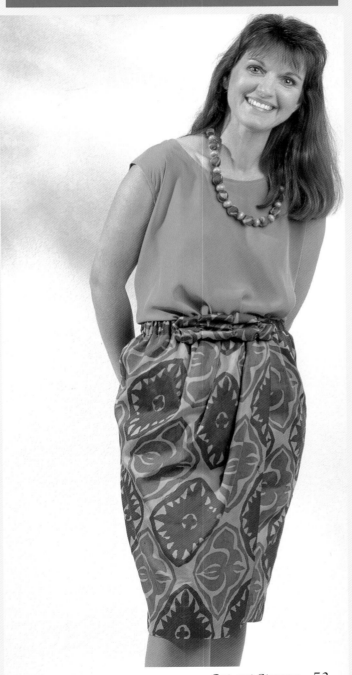

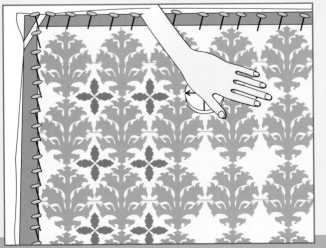

1. Make starburst and lily stamps (p12) using the patterns on p79.

2. Soak fabric in fix solution (p8). Wring out. Stretch fabric taut on plastic-covered tackboard. Pin down every 1-1/2 in. Let dry.

3. Using dressmaker's chalk, rule a graph on fabric surface as follows: Measure and mark fabric 5 in from left top and bottom edge of fabric, as shown. Continue along length of fabric marking a point every 10 in top and bottom. Join these marks with ruled chalk lines, as shown. Measure down from top corners and mark 4 in on each side, as shown. Continue down each side marking a point every 8 in. Join these marks with ruled chalk lines, as shown.

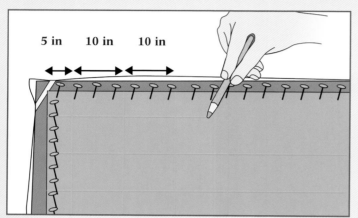 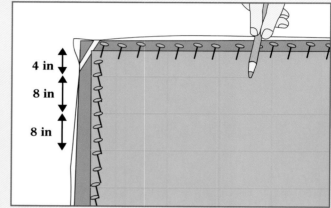

4. Mix 3 tins Mexican red dye into 2 cups prepared paste. Pour into paint tray.

 Using sponge roller, coat starburst stamp each time you print, and stamp in rows on fabric centering each pattern at the juncture of chalk lines. Align stamp with chalk lines, as shown.

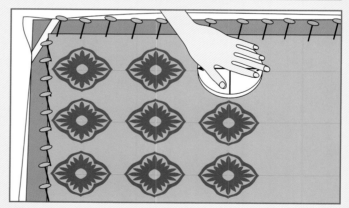

5. Mix 3 tins turquoise saga dye into 2 cups prepared paste. Pour into paint tray.

 Using clean roller, coat lily stamp each time you print. Stamp in alternate spaces between the red patterns, keeping stamp at right angles, as shown.

6. Cover with plastic. Leave overnight. Uncover, let dry, and wash out (p9). Allow to dry and press. Fabric can now be used with a pattern of your choice.

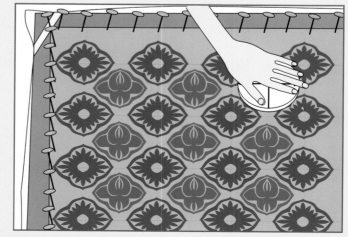

T-Shirts

MATERIALS FOR FROG T-SHIRT

tracing paper · pencil · frog pattern (p77) · piece of styrofoam and heavy felt, each 3-1/2 in x 4-1/2 in · scissors · craft knife · fabric glue · newspaper · tackboard (p6) · plastic sheet · prewashed black T-shirt with pocket · straight pins · masking tape · 1 bottle metallic copper fabric paint · 2 paint trays · sponge roller · 1 squeeze bottle each of dimensional fabric paint—metallic gold and silver · 1/2 in flat brush

1 Make the frog stamp (p12) using the pattern on p77.

2 Place several thicknesses of newspaper inside the T-shirt and in the pocket to prevent paint seeping through. Stretch the T-shirt taut onto the plastic-covered tackboard and pin down firmly.

3 Make a guideline for the design by pressing down a length of masking tape from the shoulder seam of the shirt to the hem. This will be the outside edge of the line of frogs to be printed.

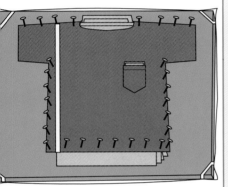 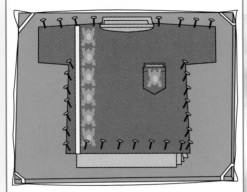

4 Pour metallic copper paint into a paint tray. Dip in roller and apply paint to the felt surface of the stamp. Squeeze a small amount of metallic gold paint into a second tray. Using brush, apply over copper on center of frog stamp, as shown.

5 Print a row of frogs, facing in any direction, from the collar to the hem, using the tape as a guide. Print a frog in the center of the pocket. If desired, turn the T-shirt over, pin down, apply tape as for front, and print another row of frogs on the back. Allow to dry. Remove masking tape.

6 Squeeze out 2 large blobs of metallic gold paint for eyes at each corner of frog's heads, as shown. Before this dries, squeeze out a smaller dot of metallic silver in the center of each eye. Allow to dry.

7 Set colors according to the manufacturer's directions.

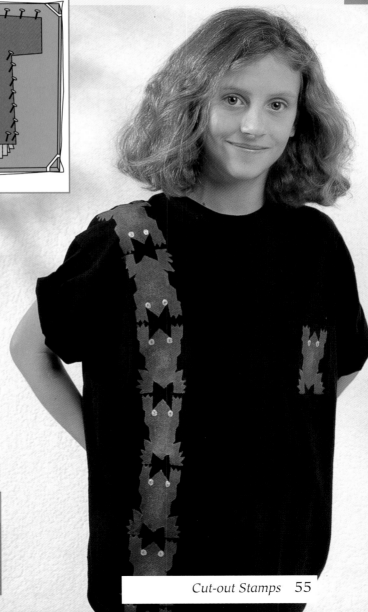

1 Make stamp (p12) using lizard pattern on p77.

2 Place several layers of newspaper under each side of cardigan front to prevent paint seepage. Stretch cardigan taut onto a plastic-covered tackboard and pin securely.

3 Measure cardigan from neck to hem. Calculate the number of lizard patterns to be fitted in, allowing 5-1/2 in for each lizard plus 1/4 in space between. Leave any extra space at top rather than print a partial pattern.

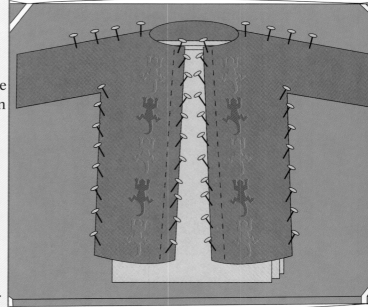

4 Pour metallic copper paint in one paint tray and metallic red in the other. Dip roller in copper and coat stamp.

5 Print lizard at hem on both sides of the cardigan front, as shown, keeping the center of lizard parallel to the edge of the cardigan. Remove excess copper paint by repeated stamping onto paper towels. Stamp does not need to be washed.

Dip another roller in metallic red paint and print above first lizard patterns on each side, as shown. Continue the 2 rows of printed lizards up each side of cardigan front, alternating copper and red, removing paint from stamps on paper towels between colors.

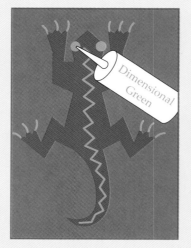

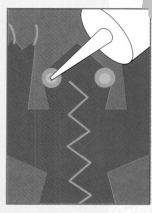

6 Using blue dimensional paint on the copper and green dimensional paint on the red, draw a zigzag line down the back and tail of each lizard, and add claws and circles for eyes, as shown.

Using metallic gold dimensional paint, fill in the center of each eye circle.

7 Set fabric paints according to the manufacturer's instructions.

Combining
Stencils
& Stamps

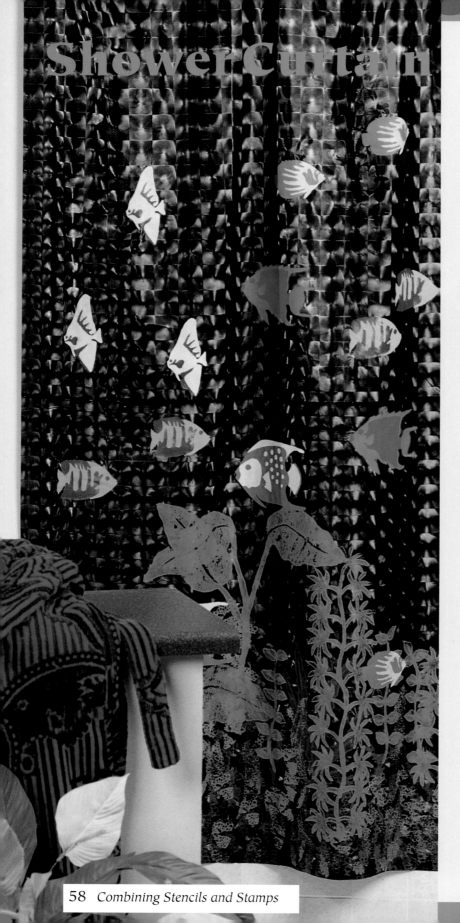

Shower Curtain

1 Make vegetation stamps (p12) using patterns on pp80–1.

2 Stretch the plastic shower curtain, right side up, on a large flat work surface (p6). Hold down edges with pieces of masking tape. Begin with bottom section of curtain.

3 Pour green paint into 4 paint trays. Leave one tray unmixed. Add white paint to 1 green paint tray and stir. Add yellow to a third green tray and stir. Add yellow and white to a fourth green tray and stir. Set aside in order: green 1, pale green 2, yellow green 3, pale yellow green 4.

green

green and white

green and yellow

green, yellow, and white

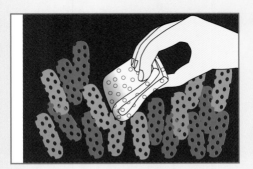

4 Begin printing green vegetation at the bottom of curtain using a coarse sponge as a stamp. Bend the sponge, holding the ends, as shown, and dip the curved section into green 1 paint. Make vertical marks by pouncing sponge lightly onto curtain. Repeat 3 or 4 times without refilling with paint. Print to a depth of 8 to 10 in from bottom of curtain. This pattern represents seaweed.

5 Repeat this sponge procedure on top of wet green color with second and third green colors.

6 Using the 2 long grass-like stamps, and paint trays 3 and 4, coat paint on stamps with roller and print clumps of foliage, as shown. Grass stamps are made in 2 pieces, put together, to create center leaf vein.

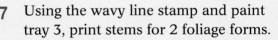

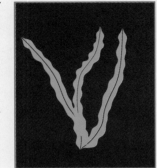

7 Using the wavy line stamp and paint tray 3, print stems for 2 foliage forms.

8 Print small leaf-like shapes and small branch-like shapes up each side of the stem, as shown. These multiple plant forms are repeated at random along the lower section of the curtain, on top of the sponged effect.

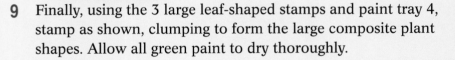

9 Finally, using the 3 large leaf-shaped stamps and paint tray 4, stamp as shown, clumping to form the large composite plant shapes. Allow all green paint to dry thoroughly.

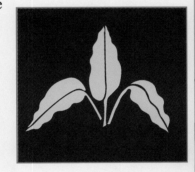

10 Make fish stencils (p10) using the patterns on pp81–4. Each fish requires 2 stencils—the first silhouettes the whole fish, the second provides decorative details. Each stencilled fish is repeated several times. Spray back of one fish stencil with repositionable spray adhesive. Position and press on curtain.

11 Using 3/4 in brush and turquoise paint, stipple (p11) over stencil. Make several fish across curtain using this pattern. Print some fish on top of vegetation. Allow to dry thoroughly. Clean stencil by placing it, sticky side down, on a sheet of wax paper. Wipe off excess paint with a paper towel.

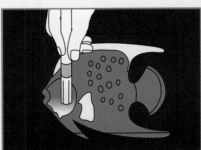

12 Place the second fish detail stencil over each printed silhouette fish on the curtain lining up details, as shown. Using the smallest stencil brush dipped in yellow paint, stencil in the details on top of the first color. Clean stencil.

13 Repeat for each of the other fish patterns, combining colors, as shown in the photograph, using clean dry stencil brushes.

14 Using a small brush and contrasting paint, add an eye to each fish, as required. Allow paint to cure for several days before using the shower curtain.

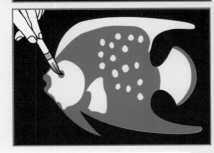

Chest of Drawers

MATERIALS

5-drawer chest (new unpainted or used) • wood fill • fine sandpaper • 1 qt blue high gloss enamel paint • 1 pt each high gloss enamel paint—red, yellow • 4 paint trays • flat paint brushes, 1 in and 2 in wide • tracing paper • pencil • clown, elephant, horse, leopard, tent, flower patterns (p85–8) • clear mylar, 12 in x 24 in • waterproof fine-tipped felt marker • craft knife • scissors • repositionable spray adhesive • 1 tube each of acrylic paint—aqua, orange, pink, purple, yellow-gold • 2 stencil brushes, 3/4 in wide • stencil brush, 3/8 in wide • paper towels • wax paper • piece of styrofoam and heavy felt, each 2-in x 3-1/2 in • fabric glue

1 Remove drawer pulls. Fill all cracks with wood fill on used chest. Allow to dry. Sand surface of chest. Remove drawers.

2 Pour blue, red, and yellow paints in separate paint trays. Paint body of chest blue. Paint 3 drawers red. Paint remaining 2 drawers yellow. Apply 3 coats of paint for each color, allowing each coat to dry before adding the next coat. Set aside for paint to cure (about 1 week).

3 Make the clown, elephant, horse, leopard, and tent stencils (p10) using the patterns on pp85–8.

4 With a pencil, mark the center of each drawer. Place each stencil in turn to the right of this mark so that multiple images will be parallel to the drawer bottom and equidistant to the top and bottom. Draw a line with the felt pen on each mylar stencil along the bottom of the drawer. Use this guideline to position each stencil.

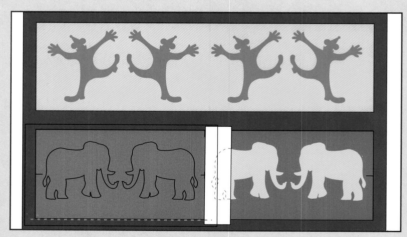

5 Lightly spray the backs of each stencil with repositionable spray adhesive.

6 Squeeze aqua, orange, red, pink, purple, and yellow-gold acrylic paints into trays.

7 Using the stencil brushes, paint each stencil separately to right and left of center of each drawer, using the following color scheme:

on yellow drawers—clowns aqua,

on red drawers—elephants pink, horses purple, leopards yellow-gold.

On blue sides of chest of drawers, paint the clowns orange and the tent red.

NOTE Before repositioning each stencil, place stencil, sticky side down, on a piece of wax paper, and clean off the excess paint with a paper towel. To avoid unwanted lifting of paint from the stencilled surfaces on the other side of the drawer, place a clean piece of paper where the sticky stencil would otherwise touch it.

8 Make flower stamps (p12) using the patterns from combining small stamps on p86.

9 Using matching colors as for the stencils, paint flower stamp surfaces with 1 in flat brush and apply to the drawers and sides of the chest, as shown.

Replace drawer pulls.

Jungle Floor Mat

MATERIALS

tracing paper · leaf and butterfly patterns (pp89–93) · styrofoam and heavy felt pieces: 2 each 8 in square, 2 each 5 in x 12 in, 2 each 9 in x 4 in, 1 each 6 in x 7 in, 1 each 2 in x 3 in, 1 each 5 in x 4 in · fabric glue · scissors · craft knife · cotton canvas, 31 in x 41 in · iron · newspapers · 1 qt mustard-yellow latex paint · large paint tray · large paint roller · plastic-covered tackboard (p6) · straight pins · latex paint: 1 pt green, 1/2 pt each blue, white, yellow · 7 paint trays · 3 small sponge rollers · paper towels · cheetah pattern (pp94–5) · 2 pieces mylar, each 12 in square · repositionable spray adhesive · small bottle acrylic paint: orange, brown · stencil brush, 3/8 in wide · clear acrylic varathane

1 Make 8 leaf stamps and a butterfly stamp (p12) using patterns on pp89–93.

2 Turn under 1/2 in on all sides of canvas. Press down with iron set at "cotton." Glue with fabric glue. Lay canvas on newspaper-covered work surface.

3 Pour mustard-yellow paint into paint tray. Dip in large roller and coat surface of canvas. Allow to dry. Give canvas a second coat. Pin to tackboard. Allow to dry.

4 Pour equal amounts of green latex paint into 7 trays. Leave paint tray 1 green. In equal quantities, add mustard-yellow to paint tray 2, blue to tray 3, blue and white to tray 4, yellow to tray 5, and 2 parts white to tray 6, and 3 parts yellow to tray 7. Stir.

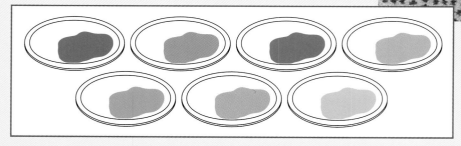

5 Dip small sponge roller in paint tray 1. Coat surface of each large leaf stamp and print both stamps 4 or 5 times each over lower section of the mat. Recoat stamp surface each time you print. Clean excess paint off stamps by pressing onto paper towels.

6 Repeat stamping procedure using paint tray 2 and same stamps, overlapping some of the previous leaf patterns.

7 Repeat stamping procedure using paint tray 3 and 2 fern stamps. Overlap previous pattern. Stamp some as silhouettes against the unprinted upper sections, as shown.

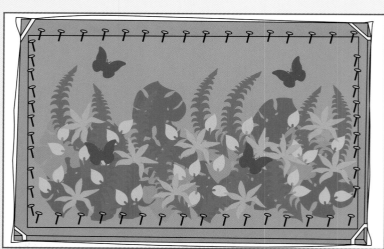

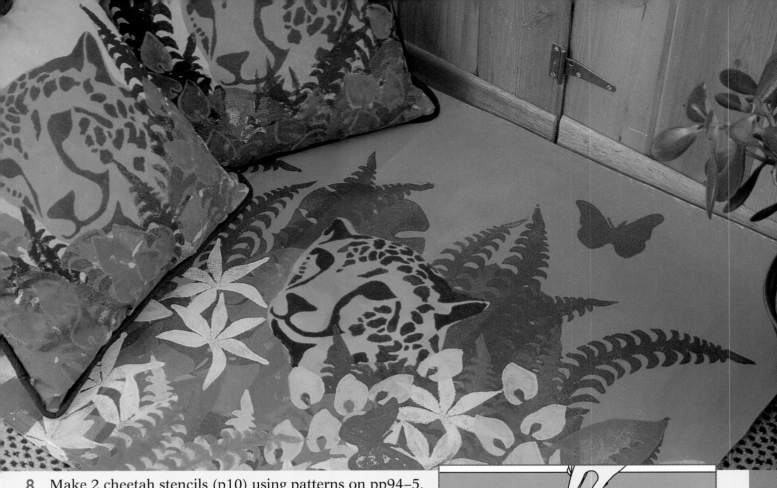

8 Make 2 cheetah stencils (p10) using patterns on pp94–5.

9 Spray back of stencils with repositionable spray adhesive. Press cheetah silhouette stencil onto center of canvas.

10 Pour orange paint into clean paint tray. Dip small sponge roller into orange paint (do not overload) and gently paint over stencil. Remove stencil. Allow to dry.

11 Position second "spot" stencil over cheetah silhouette.

12 Pour brown acrylic paint into clean paint tray. Using stencil brush, stipple (p11) paint through openings. Lift stencil. Allow to dry.

13 Using paint tray 3, print fern patterns to overlap lower section of cheetah, as shown. Clean excess paint off stamps by pressing onto paper towels.

14 Using paint tray 4 and 2 medium-sized leaf stamps, and paint tray 6 and segmented leaf stamp, print leaves randomly overlapping one another. See photo.

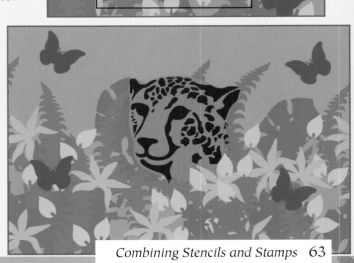

15 Using paint tray 7, print small leaf stamp in clumps and using paint tray 5 and 7, print fern stamp several times along bottom edge. *See* photo.

16 Pour blue paint into clean tray and dip in clean sponge roller and coat and print 4 butterflies–2 overlapping foliage and 2 in "sky" section. *See* photo.

17 Using clean roller and tray, pour in clear acrylic varathane and apply 3 coats to mat, allowing time to dry between coats. Turn over and apply 2 coats to underside. Allow time to dry between coats. Allow 1 week before laying on floor.

& Pillow Covers

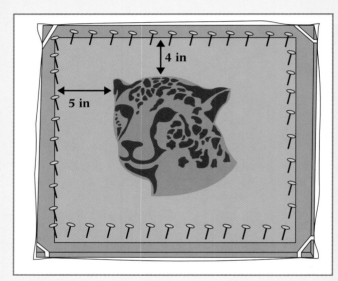

1 Stretch fabric taut over plastic-covered tackboard. Pin down along sides.

2 Position cheetah silhouette stencil on fabric with top of head 4 in from top edge and left ear 5 in from left side, as shown. Press down firmly. Paint cheetah silhouette orange and "spots" brown, as per floor mat instructions.

3 The pillows in photo use green for ferns, yellow-green for large leaves. and orange for small oval leaves. The jungle foliage is printed around and in front of the cheetah head. Overlap leaf stamps as per floor mat instructions.

4 Set fabric paints according to manufacturer's instructions. Finish pillow covers with cord edging and complementary backing fabric.

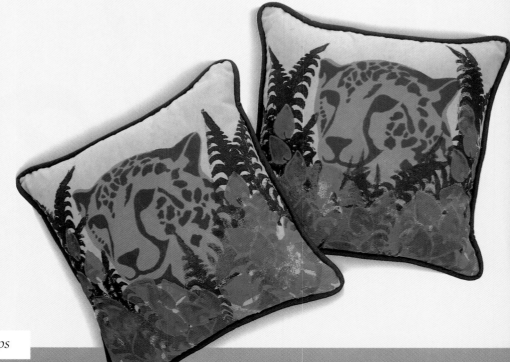

Stencil & Stamp Patterns

> **For sizing reference, patterns in this book are placed on grid work**
> **1 square = 1 inch (2.5cm)**
>
> Grid work can be used to enlarge, reduce, or change the dimensions of a design. On paper large enough to accommodate the desired size, draw a new grid work with the size of squares adjusted to fit the new grid. Copy the design from the original grid onto the modified one, square by square.

Flower Pot p21
unfolded pattern

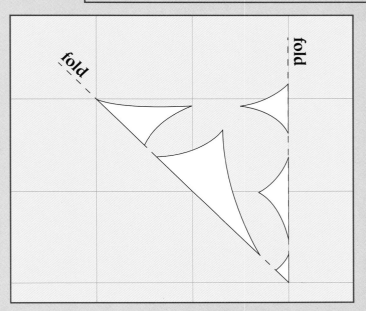

Flower Pot p21
Folded and cut-out stencil pattern

Wastebasket p22
unfolded pattern

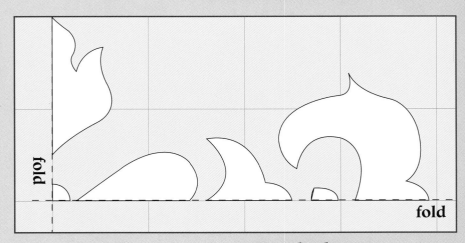

Wastebasket p22
Folded and cut-out stencil pattern

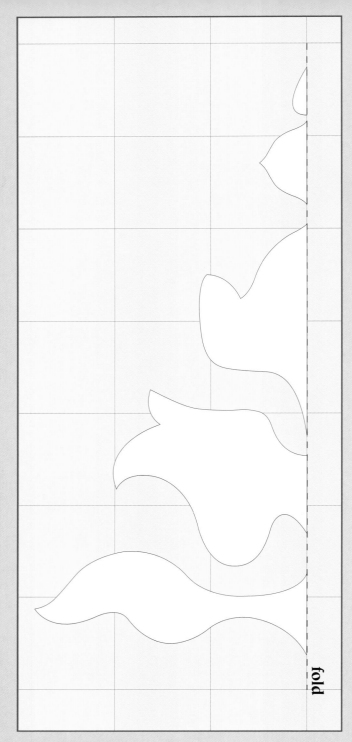

Lamp Shade p23
Folded and cut-out stencil pattern

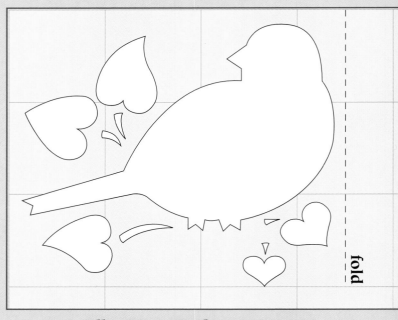

Pillow Case & Sheet p25
Folded and cut-out stencil pattern

Pillow Case & Sheet p25
unolded pattern

**Umbrella p24—
first fold and cut**
*Folded and cut-out
stencil pattern*

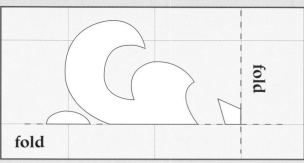

fold

fold

Umbrella p24
unfolded pattern

**Umbrella p24—
second fold and cut**
*Folded and cut-out stencil
pattern*

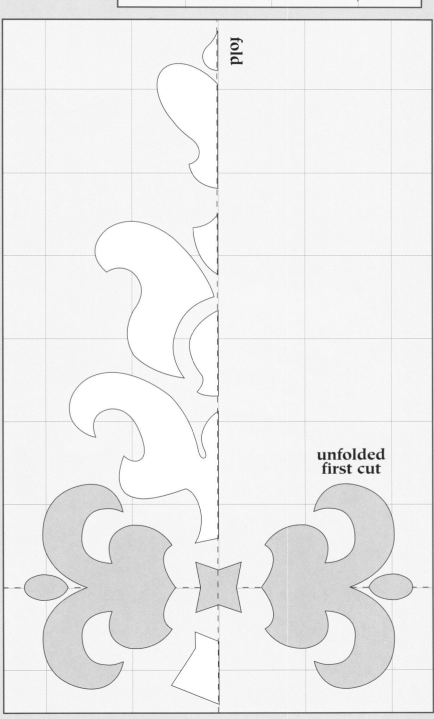

fold

unfolded
first cut

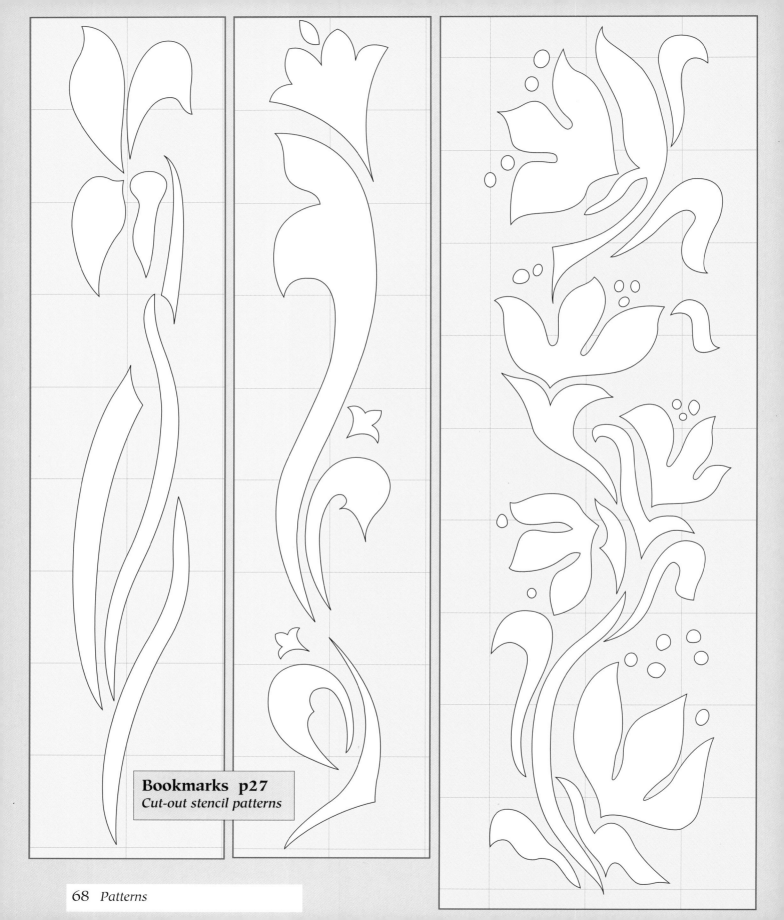

Bookmarks p27
Cut-out stencil patterns

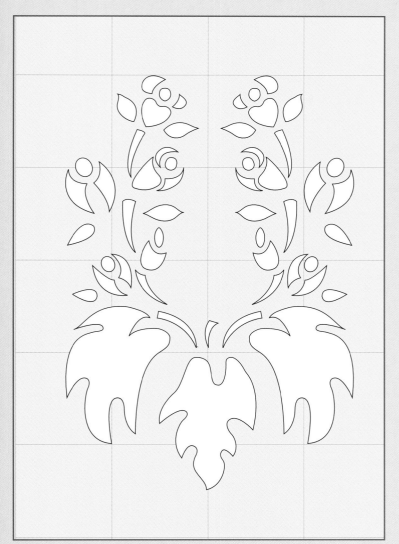

Switch Plate p30
Cut-out stencil pattern

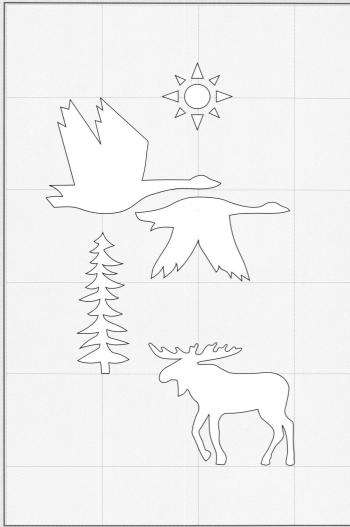

Rock Painting Paperweights p31
Cut-out stencil pattern

opposite page at right
Ribbon Hanging p28
Cut-out stencil pattern

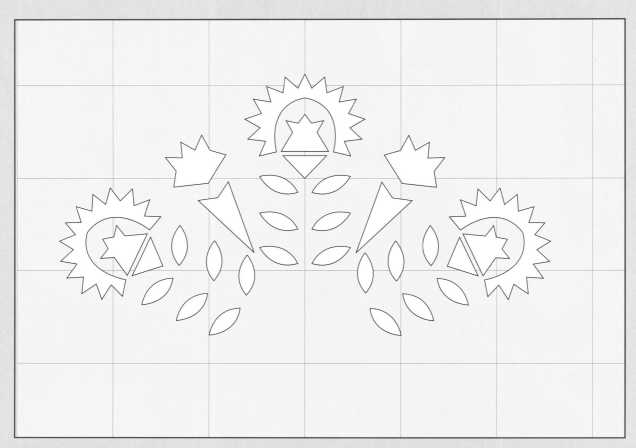

Trinket Box p32
Cut-out stencil pattern

Napkin Rings p34
Cut-out stencil pattern

opposite page
Small Stamps pp39–41
Cut-out Stamp patterns

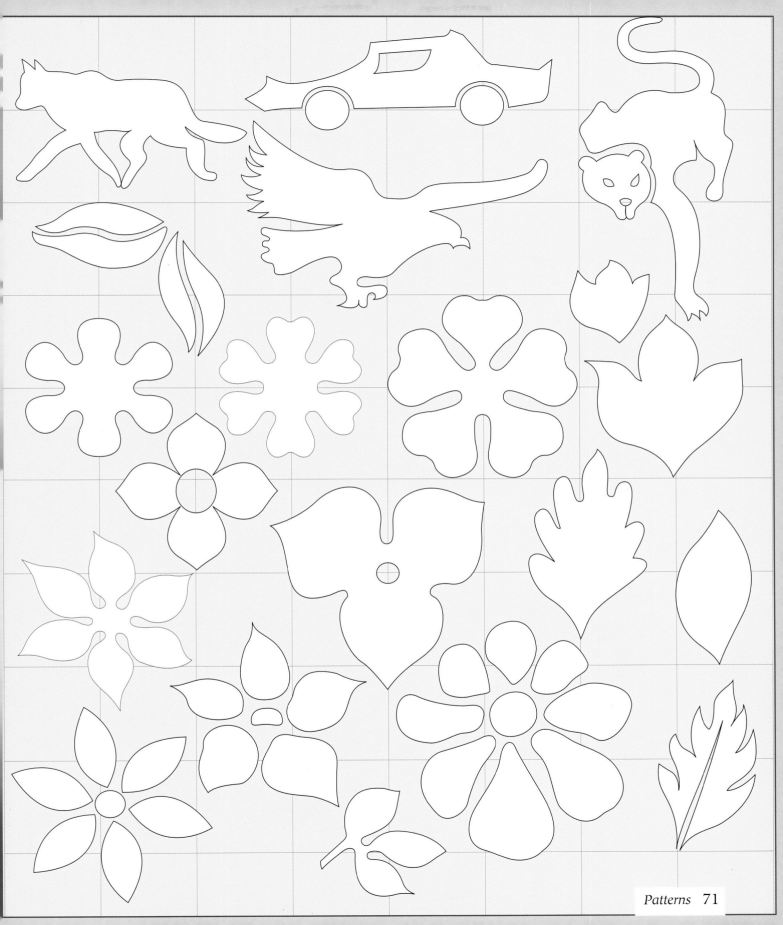

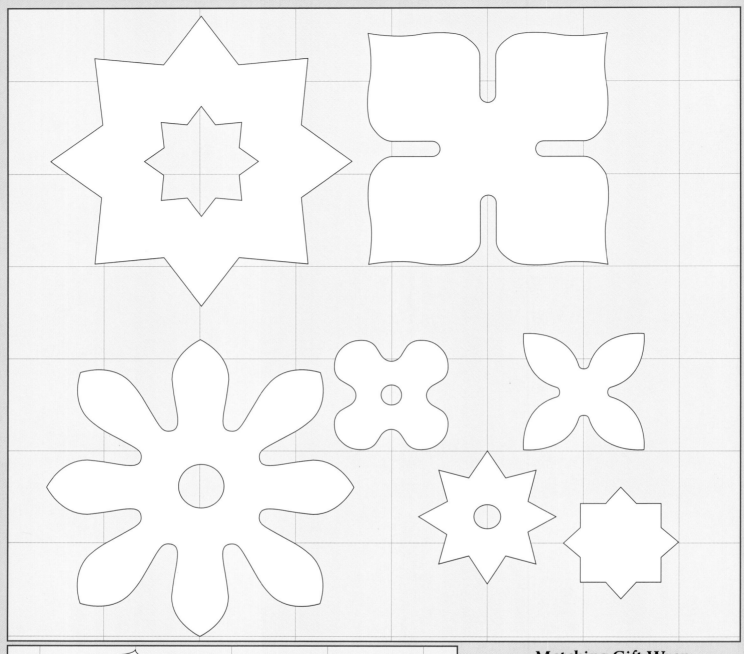

**Matching Gift Wrap,
Card, Ribbon p42**
Cut-out stamp patterns

Small Stamps pp39–41
Cut-out Stamp patterns

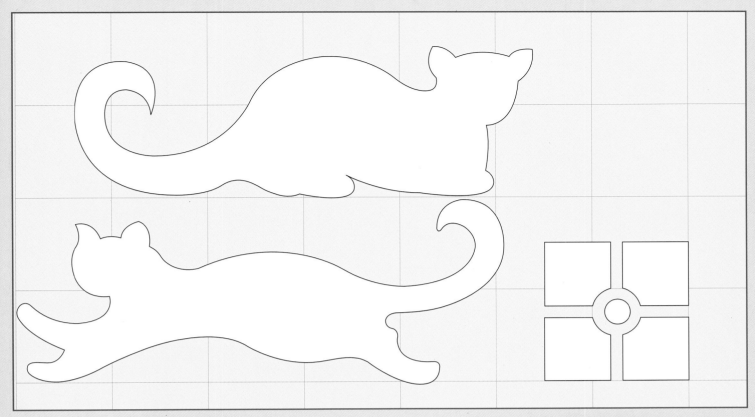

below **Place Mats p48**
Cut-out stamp pattern

above **3-Ring Binder Cover p43**
Cut-out stamp patterns

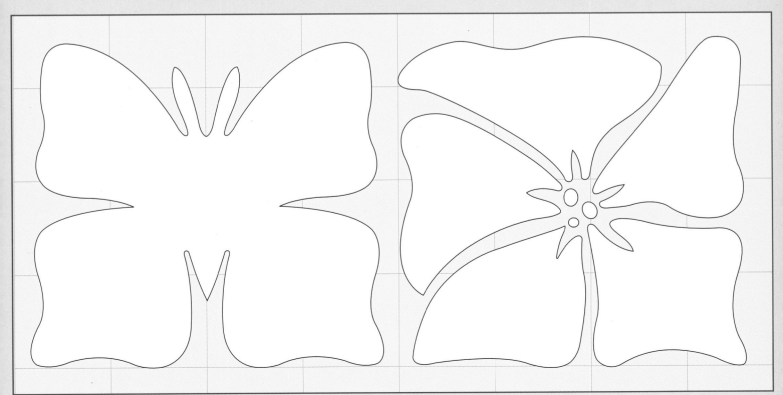

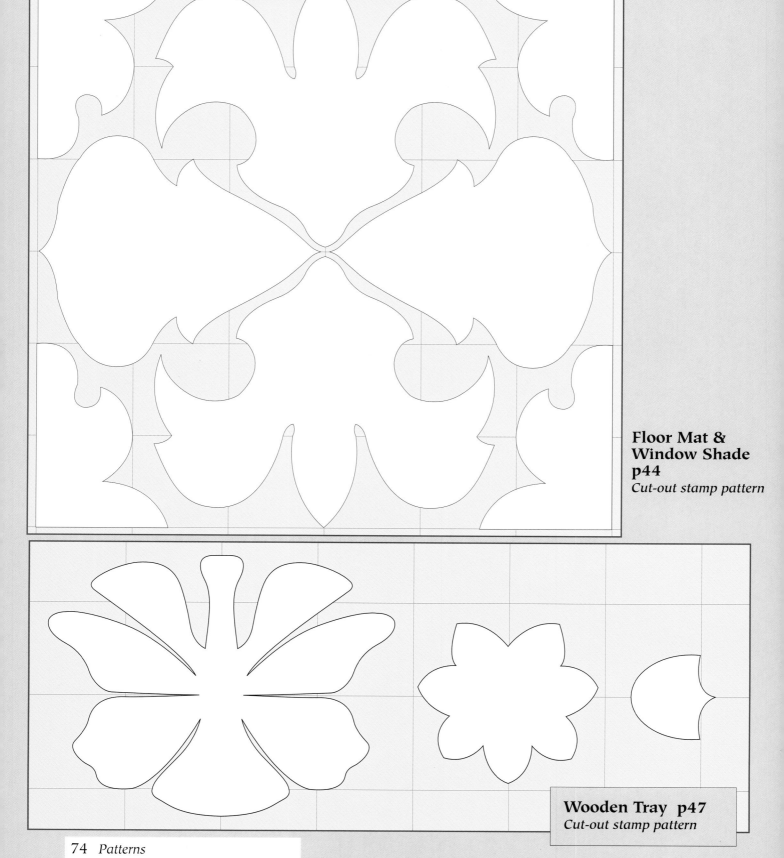

**Floor Mat &
Window Shade
p44**
Cut-out stamp pattern

Wooden Tray p47
Cut-out stamp pattern

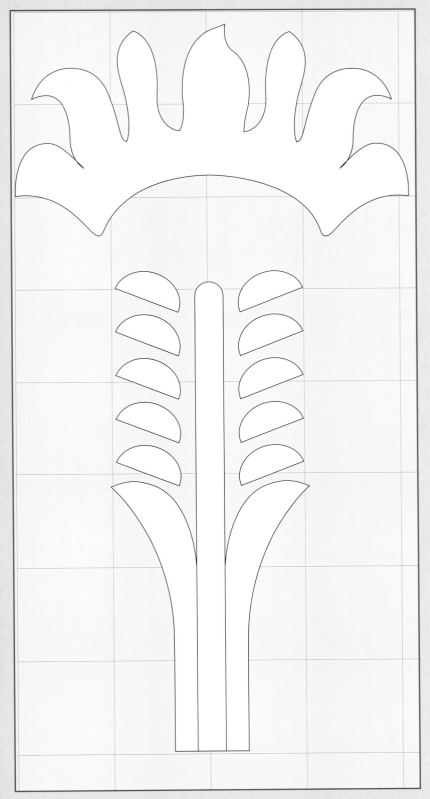

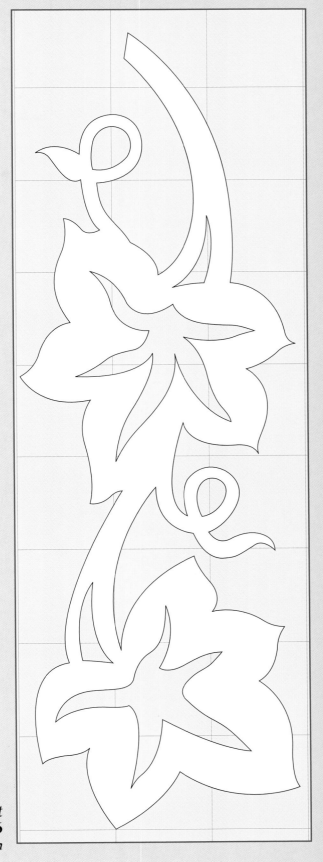

above
Wooden Tray p47
Cut-out stamp pattern

at right
Wooden Tray p46
Cut-out stamp pattern

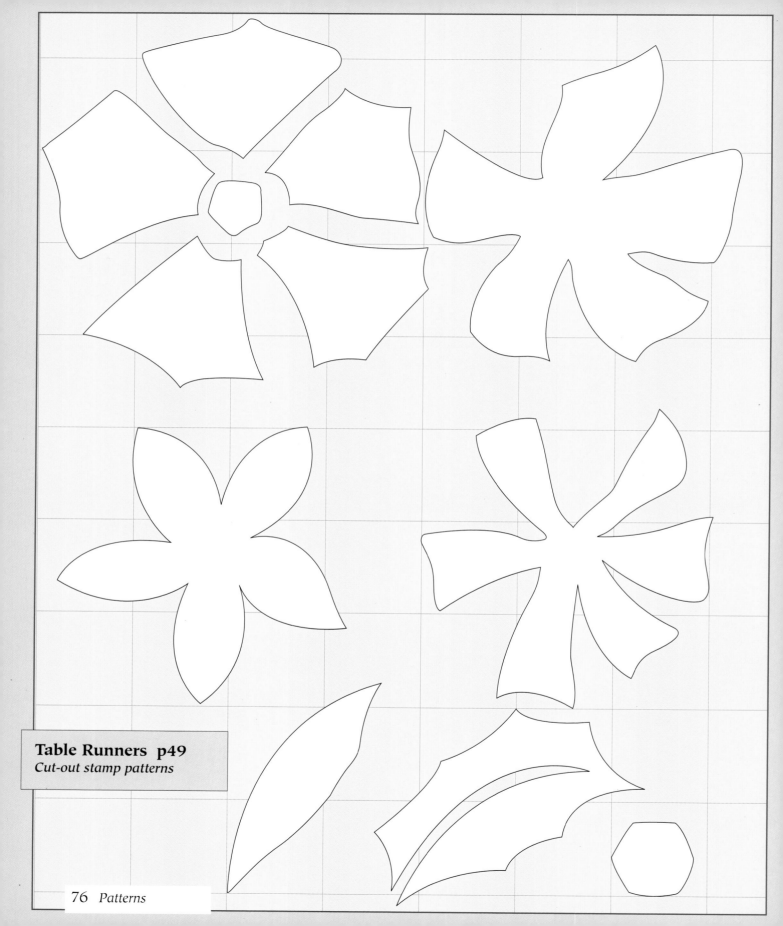

Table Runners p49
Cut-out stamp patterns

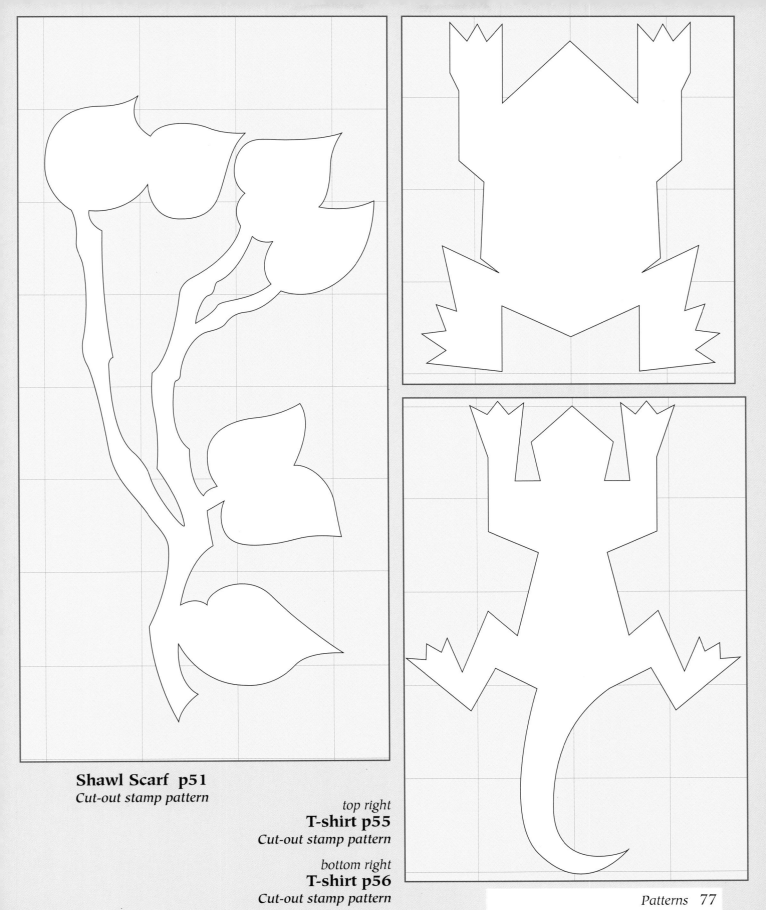

Shawl Scarf p51
Cut-out stamp pattern

top right
T-shirt p55
Cut-out stamp pattern

bottom right
T-shirt p56
Cut-out stamp pattern

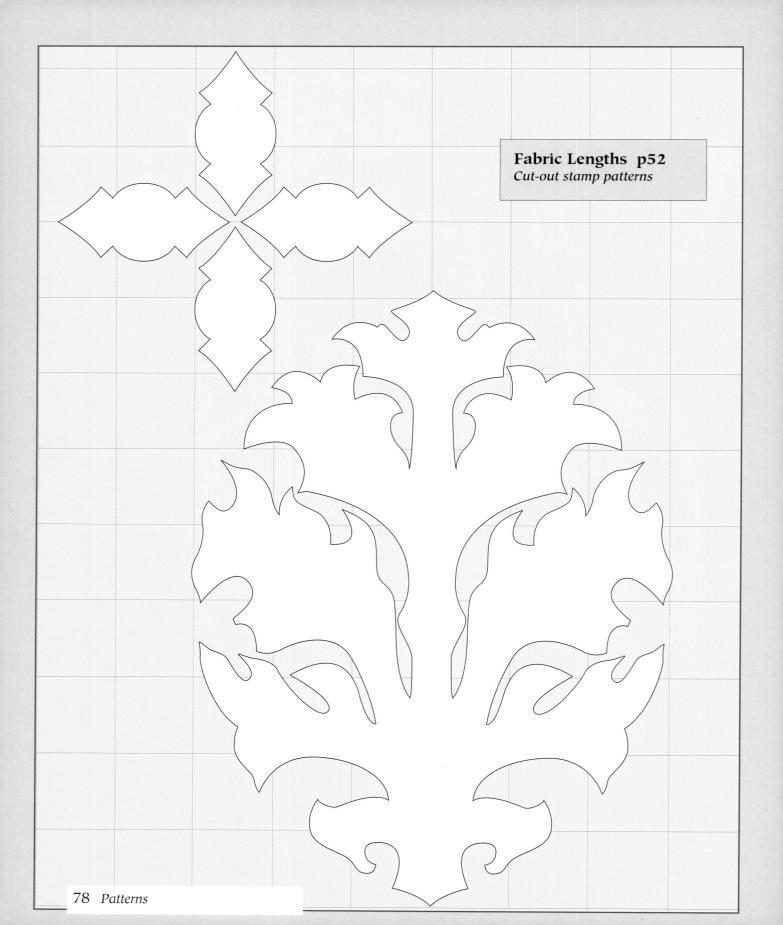

Fabric Lengths p52
Cut-out stamp patterns

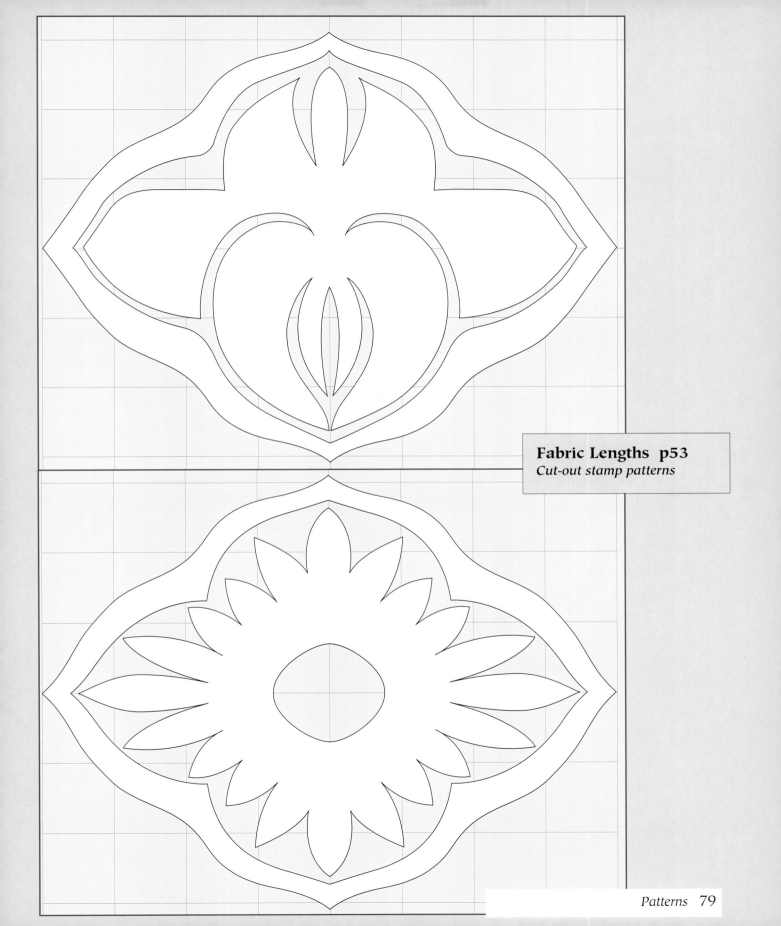

Fabric Lengths p53
Cut-out stamp patterns

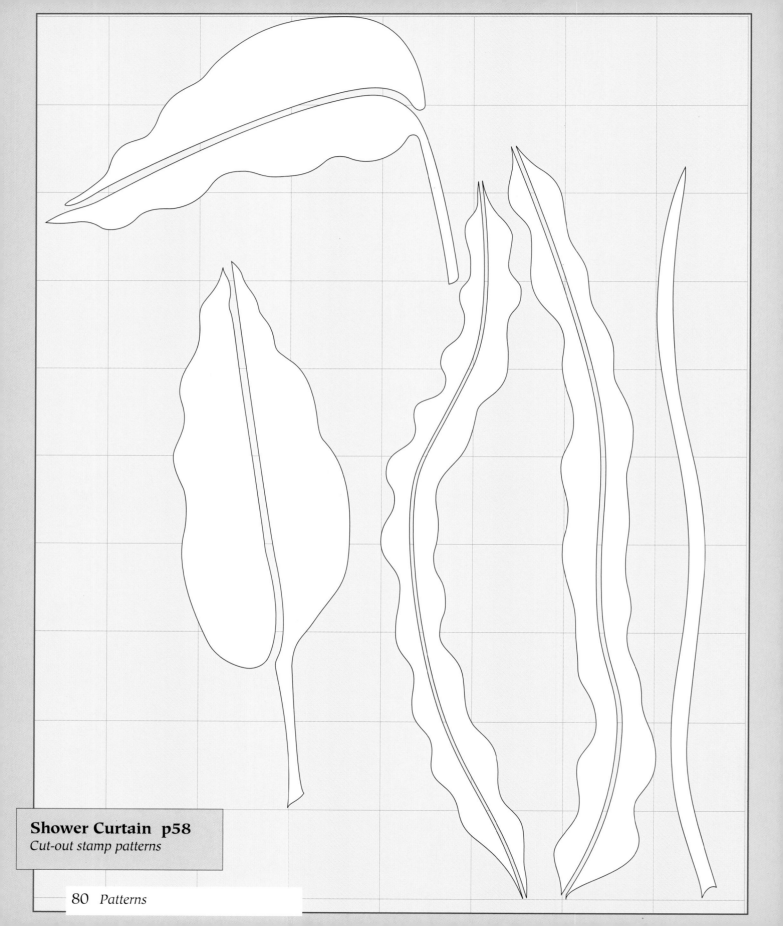

Shower Curtain p58
Cut-out stamp patterns

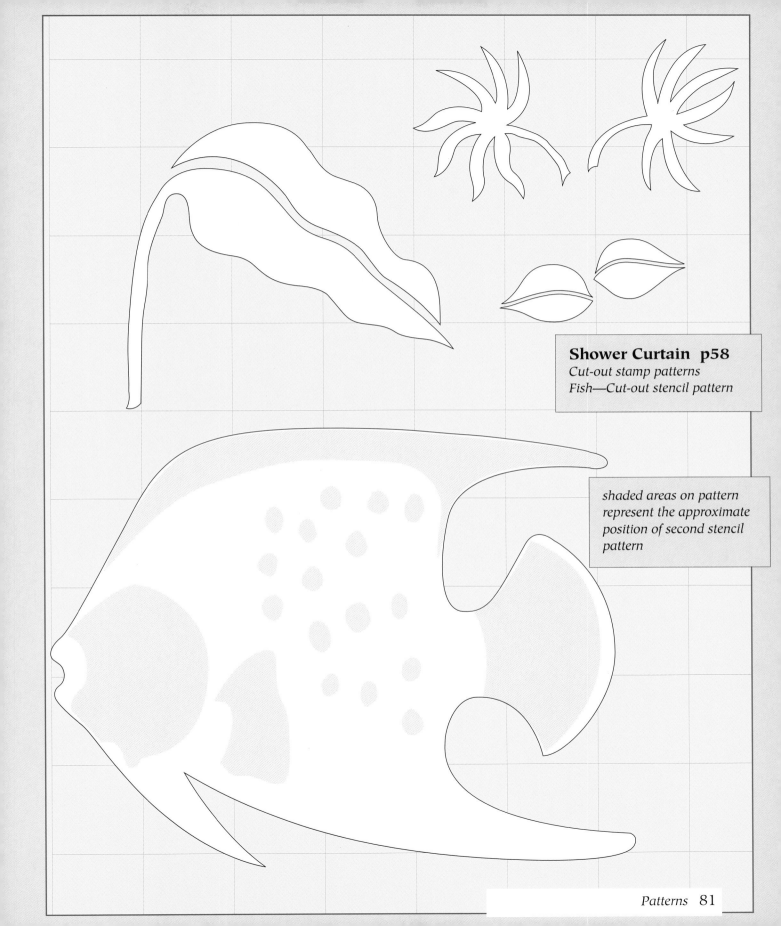

Shower Curtain p58
Cut-out stamp patterns
Fish—Cut-out stencil pattern

shaded areas on pattern represent the approximate position of second stencil pattern

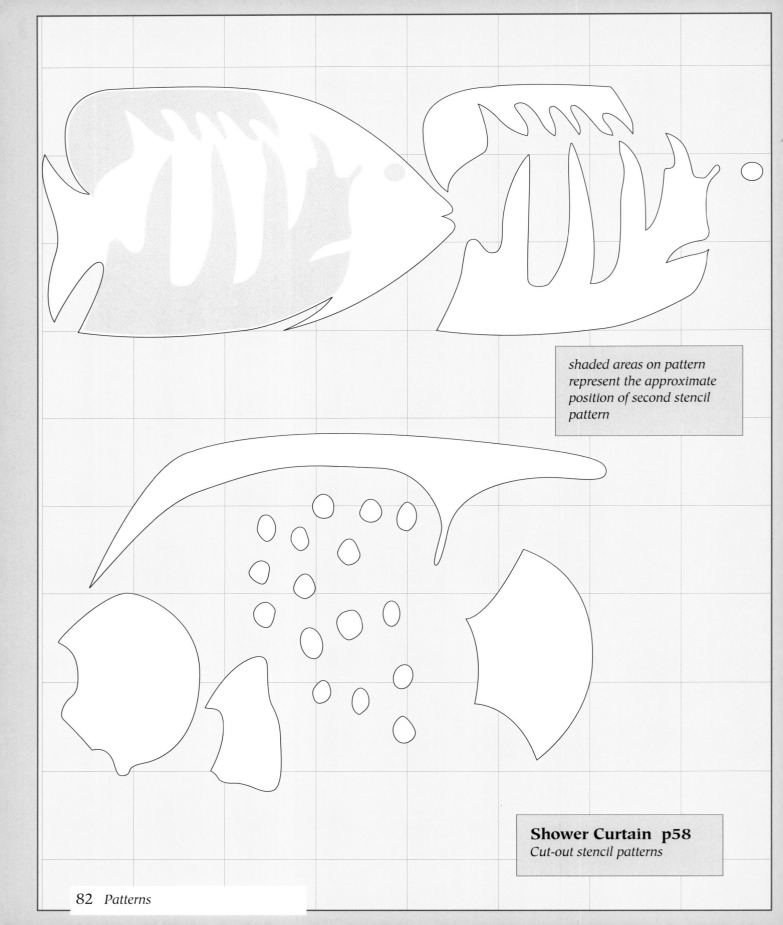

shaded areas on pattern
represent the approximate
position of second stencil
pattern

Shower Curtain p58
Cut-out stencil patterns

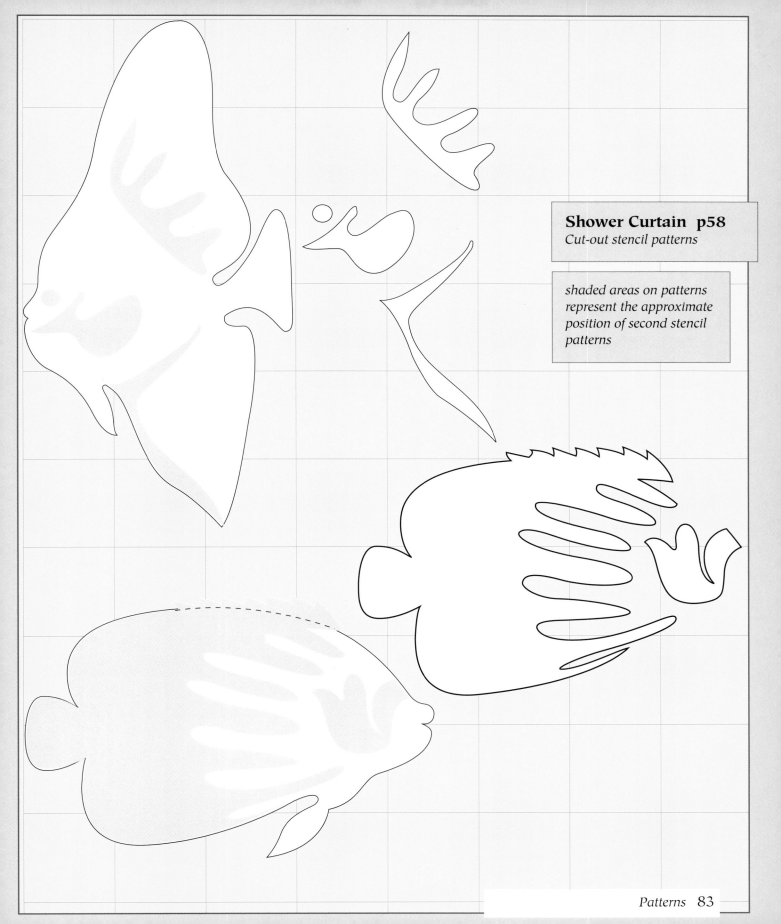

Shower Curtain p58
Cut-out stencil patterns

shaded areas on patterns
represent the approximate
position of second stencil
patterns

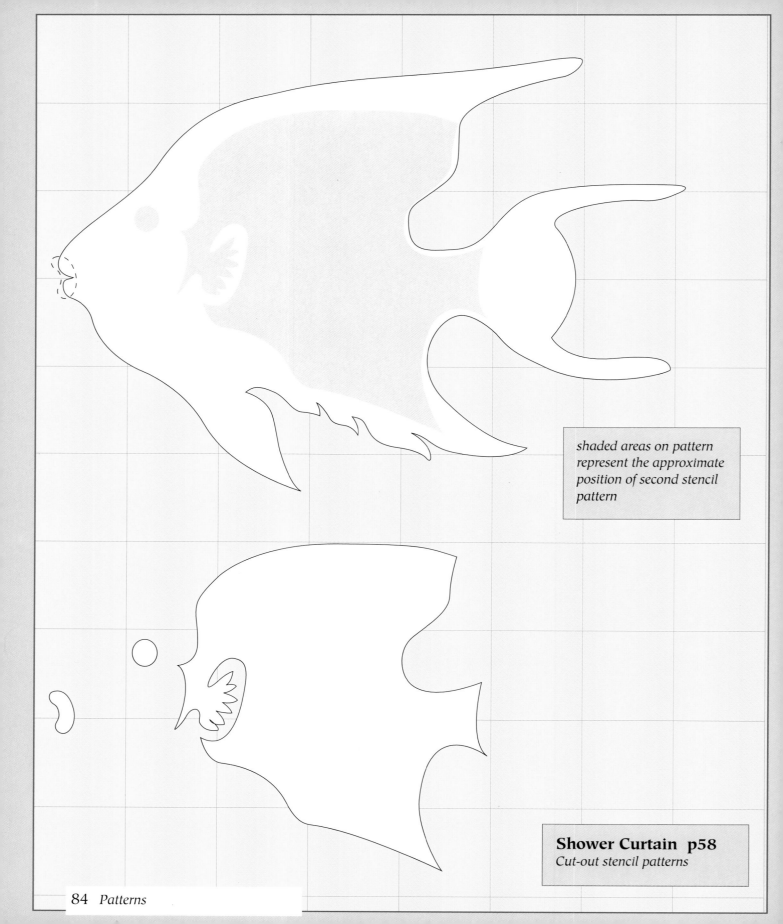

shaded areas on pattern represent the approximate position of second stencil pattern

Shower Curtain p58
Cut-out stencil patterns

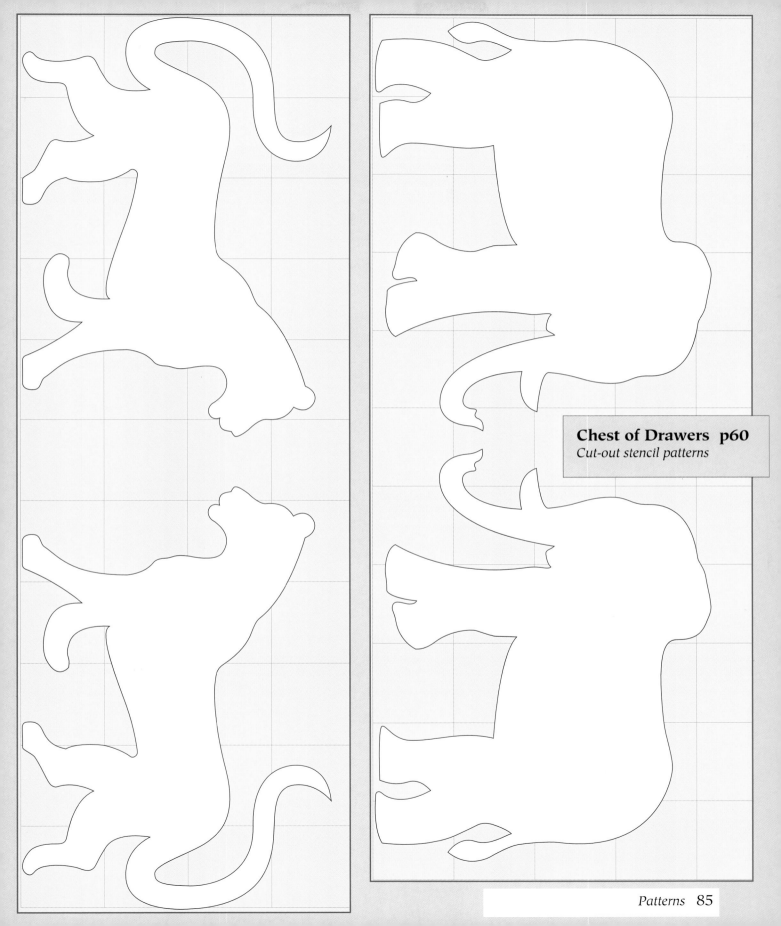

Chest of Drawers p60
Cut-out stencil patterns

Chest of Drawers p60
Cut-out stamp patterns

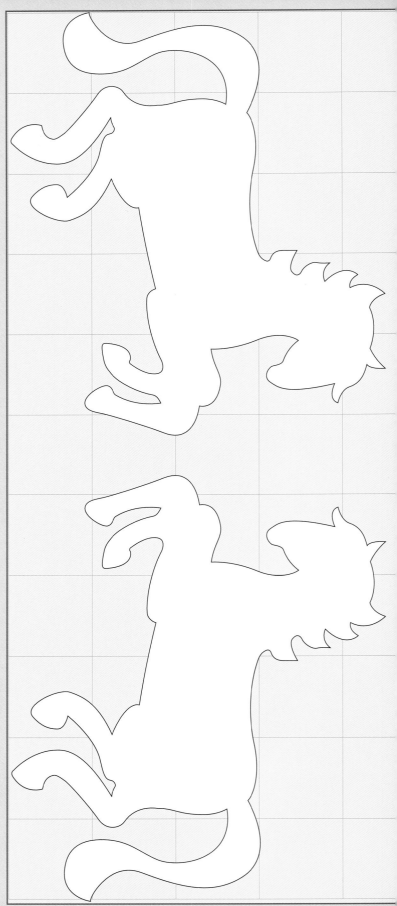

Chest of Drawers p60
Cut-out stencil patterns

86 *Patterns*

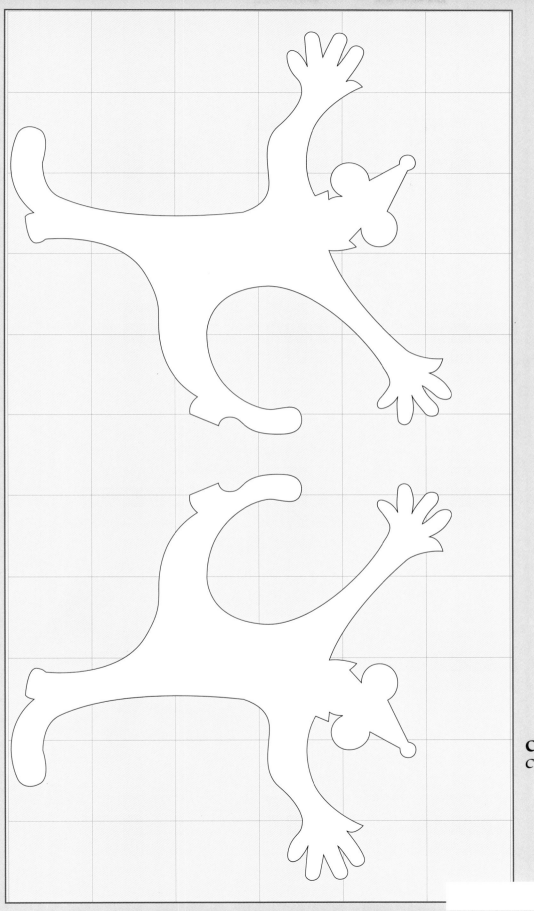

Chest of Drawers p60
Cut-out stencil patterns

Chest of Drawers p60
Cut-out stencil patterns

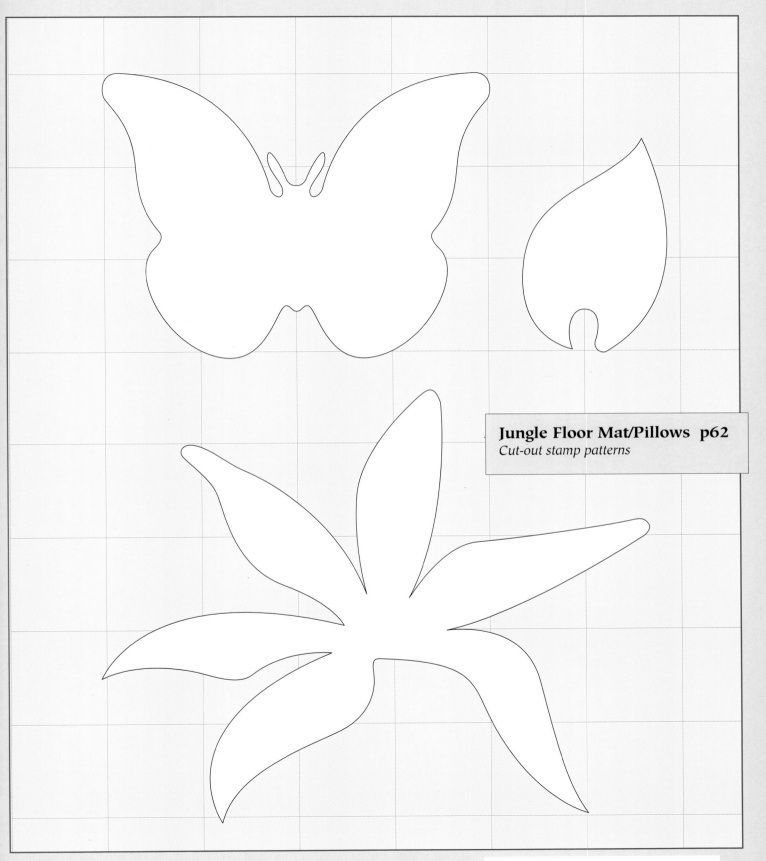

Jungle Floor Mat/Pillows p62
Cut-out stamp patterns

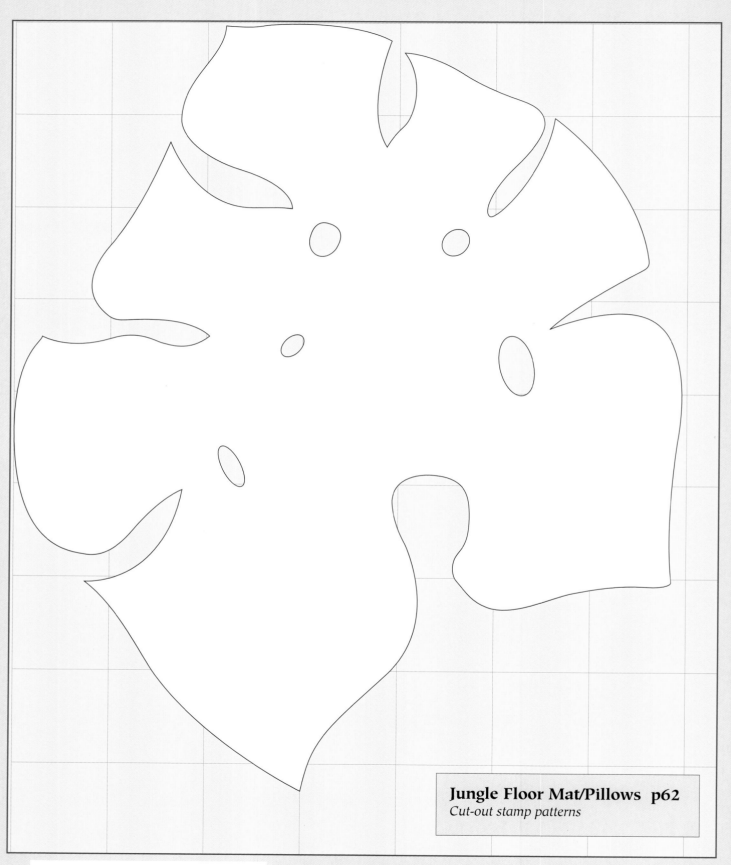

Jungle Floor Mat/Pillows p62
Cut-out stamp patterns

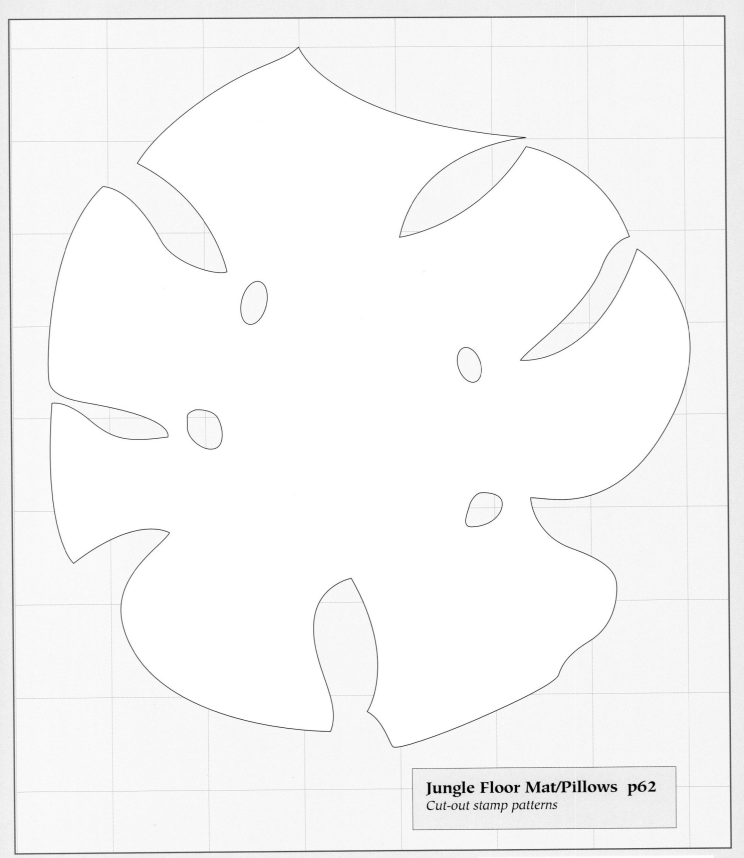

Jungle Floor Mat/Pillows p62
Cut-out stamp patterns

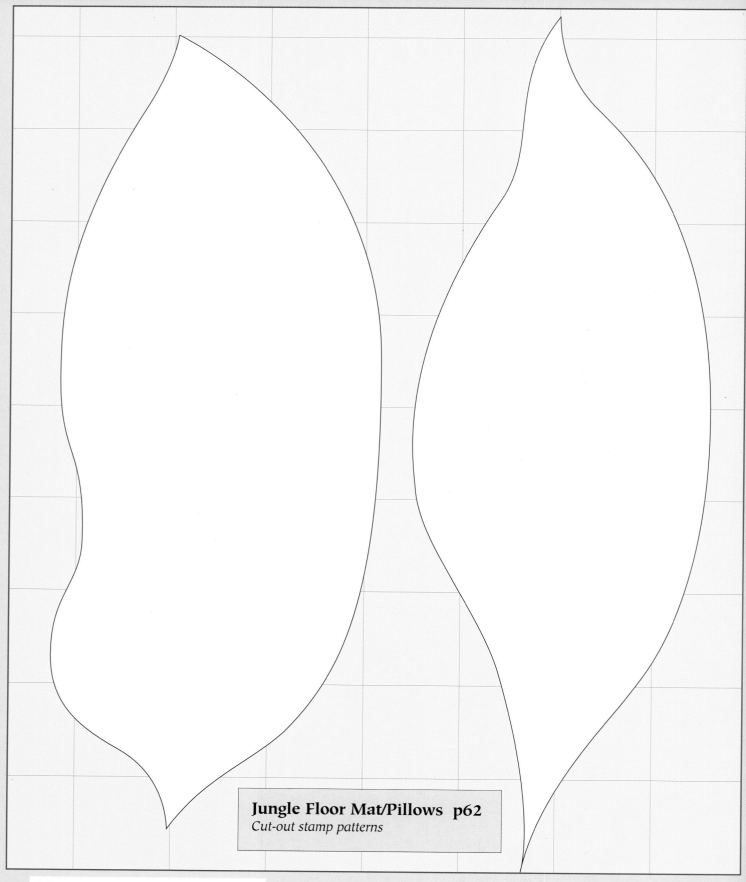

Jungle Floor Mat/Pillows p62
Cut-out stamp patterns

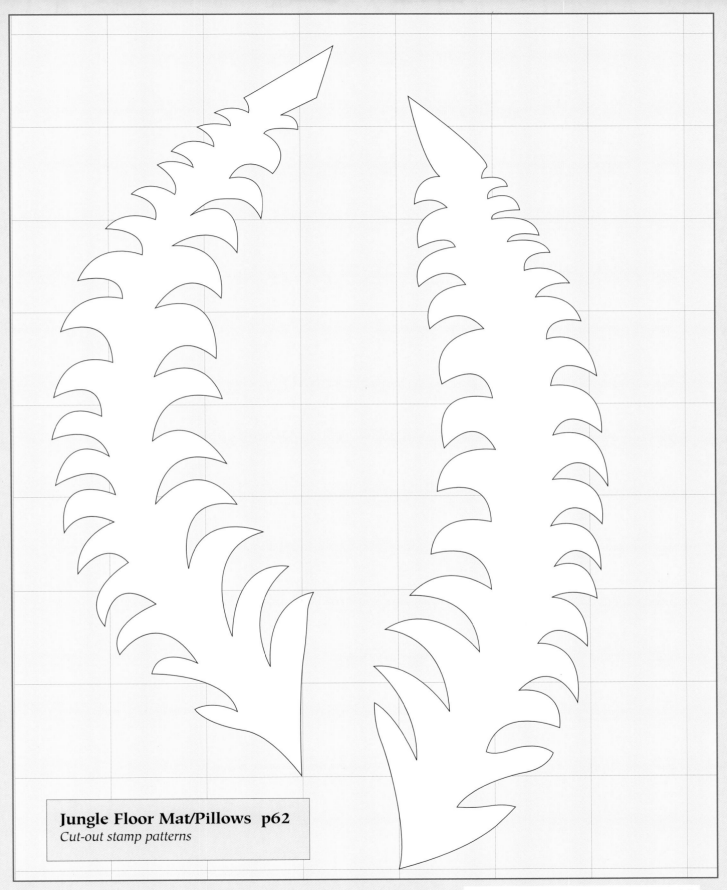

Jungle Floor Mat/Pillows p62
Cut-out stamp patterns

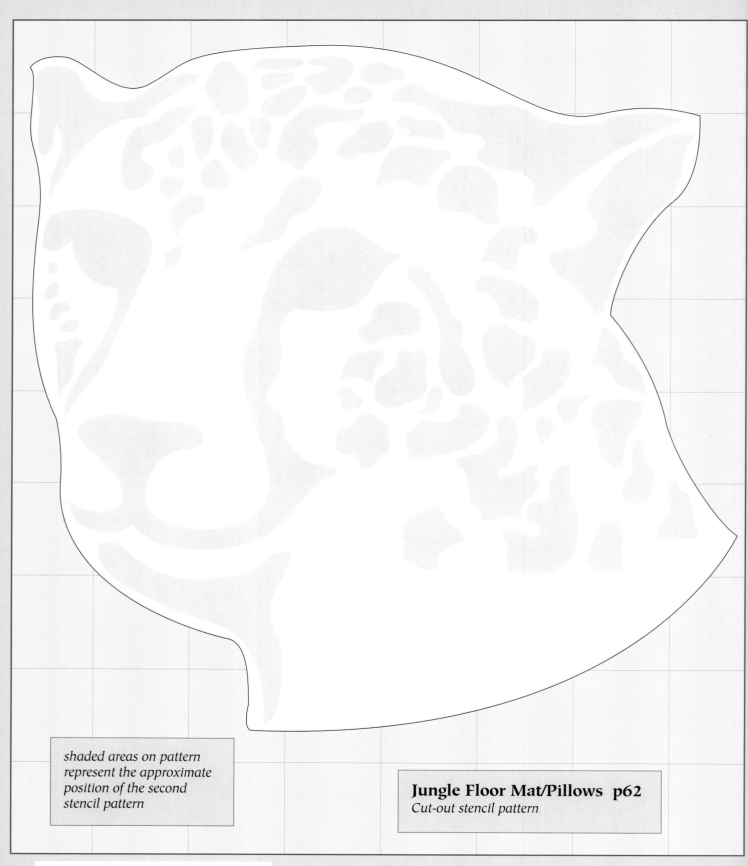

shaded areas on pattern
represent the approximate
position of the second
stencil pattern

Jungle Floor Mat/Pillows p62
Cut-out stencil pattern

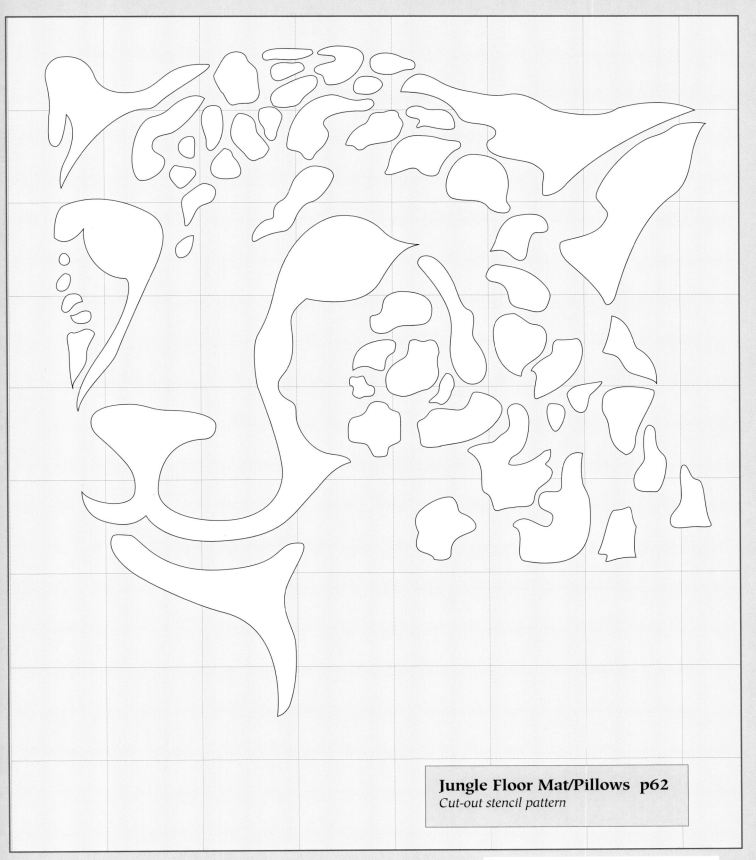

Jungle Floor Mat/Pillows p62
Cut-out stencil pattern

Index